Brooklyn Makers

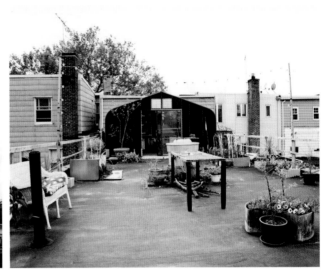

BROOKLYN MAKERS

Food, **Design**, **Craft**, and Other Scenes from the Tactile Life

Jennifer Causey

Foreword by Eric Demby

Princeton Architectural Press, New York

Contents

Foreword
Eric Demby
7

Preface
Jennifer Causey
9

Makers Map
12

NORTH BROOKLYN

Clam Lab
Ceramicist
16

hOmE
Builders
22

Bellocq Tea Atelier
Tea Blenders
26

Odette New York
Jeweler
32

Fay Andrada
Metalsmith
38

Nicolette Camille
Florist
42

Wiksten
Designer
48

MCMC Fragrances
Perfumer
52

Paulie Gee's
Pizza Maker
56

Erin Considine
Jeweler
60

Fleabags
Bag Designers
66

Mast Brothers Chocolate
Chocolate Makers
70

Morris Kitchen
Mixologists
74

Shabd
Designer
78

Blue Bottle Coffee
Coffee Roasters
84

Lady Grey Jewelry
Metalsmiths
88

Kings County Distillery
Distillers
94

SOUTH BROOKLYN

Joya Studio
Fragrance Designers
102

Lena Corwin
Printmaker
108

The Jewels of New York
Food Stylists
112

Four & Twenty Blackbirds
Pie Makers
116

Lotta Jansdotter
Designer
120

Reverie
Jeweler
126

Ovenly
Bakers
132

PELLE
Designers
136

Saipua
Florist
140

Elephant Ceramics
Ceramicist
146

Liddabit Sweets
Candy Makers
152

La Newyorkina
Treat Maker
156

Robicelli's
Bakers
160

Appendix
167

Acknowledgments
175

FOREWORD

Eric Demby

Brooklyn is not a place that lost touch with the art of making—just ask Martin Greenfield the tailor, Domenico DeMarco (of Di Fara Pizza) the pizzaiolo, Louise Bourgeois the sculptor, or even Spike Lee the filmmaker. What sets us apart today is that we all create together with a collective pride in pushing forward the *idea* of Brooklyn blazed by the great makers before us. Whether intentionally or not, emerging as the city's finest perfumer (MCMC Fragrances), chocolatier (Mast Brothers Chocolate), soapmaker (Saipua), or printer (Lena Corwin) these days sends a signal to the world that the Brooklyn of *On the Waterfront* and the Dodgers has been permanently relegated to the realm of nostalgia, replaced by a modern metropolis in which every type of art, craft, food (and beer and booze), and home or workspace is being made literally in our own backyard. And in the greatest coup of all, we work with the confidence that being the best in Brooklyn no longer means runner-up; it means being the best in New York City, and often all of America.

Brooklyn Makers appears at a moment that would have made a good cocktail-party punch line a decade ago: the second-fiddle borough is jumping the shark. From MTV sitcoms to Absolut special editions, Brooklyn is everywhere. But this book reminds us that what matters most here at home is not coolness but inspiration, expertise, and dedication. Being allowed to peer through Jennifer's perfectly framed window into the studios of Odette New York and hOmE provides

a combination of intimacy and simplicity that romanticizes the creative process while bringing it down to a universal, human scale. Kings County Distillery's whiskey bottles appear effortlessly sophisticated in their finished form; but seeing the mash stirred in an everyday steel soup pot cues thoughts of regular folks in Kentucky barns— and more importantly, it makes you believe, "Hey, I could do this too."

That infectiousness is a big part of Brooklyn's appeal. I used to think that people flocked to the Brooklyn Flea and its sister Smorgasburg food fair to buy locally and be part of an old-time town square. But more recently, I've watched as the markets evolve into a community of makers, and a resource for bakers, jewelers, furniture fabricators, and all manner of age-old craftspeople who crave a place to learn more about their new passions, with hopes of one day making a living from them. Like the rolling bar cart for sale at the Flea that's fashioned from former rail wheels, upstate barn wood, and cast-off metal piping, they delve into tradition as a starting point, then enter the modern panoply of materials and production techniques to form something entirely new.

Those vendors, like the makers in this book (many of them current or former vendors), are who today's young creators aspire to be. And in Brooklyn—maybe because of our history, maybe because of our abundant "artisanal" food—these new heroes are hardly in short supply. Maybe it's like they used to (and still) say about the Gowanus Canal: Must be somethin' in the water.

PREFACE

Jennifer Causey

The question I am asked most often is "Why did you start this project?" I'll admit, at first I was prompted by curiosity (who wouldn't want a behind-the-scenes look at the processes and studios of local makers?). Later the project grew into a bit of an obsession; each studio visit was better than the last and I was constantly driven by the discovery of new makers.

At various times in my life, I wanted to be an archeologist, doctor, advertising executive, and make-up artist, among other professions, before I finally found the right fit as a photographer. With my camera, I understand the world visually. If I want to learn about something, I have to see how it's done. During the process of this project, I found myself wanting to be a ceramicist, florist, baker, metalsmith, and tie-dyer. The work allowed me to become a small part of each trade and offered a way for me to gain a bit of knowledge from an inside perspective.

Before starting the project, I discussed it with a few friends who were very encouraging. With their shared enthusiasm, I decided to jump right in. I first made a list of potential makers to photograph. Many from this initial list were food vendors that I liked from the Brooklyn Flea (Liddabit Sweets, Robicelli's, and more). I discovered some through word of mouth and still more through other makers. While eating at Paulie Gee's, I inquired about the interior design, which was by the Haslegrave brothers of hOmE. After meeting and photographing the Haslegraves, they suggested I contact their

friends Agatha Kulaga and Erin Patinkin of Ovenly. Additionally, the Greenpoint studio complex Dobbin Mews is a collaborative home to several makers featured here, including studiomates Nicolette Camille and Fay Andrada and Odette New York, Wiksten, and MCMC Fragrances. The shared space and spirit of the place was truly inspiring. The list continues to grow; there are so many interesting makers living and working around me.

The first maker I photographed was Sarah Ryhanen from Saipua. I had known of Sarah for many years; I used to live near her original shop in Red Hook (a few blocks from her current location). For me, her store always provided a perfect respite from the city, a magical world filled with her fragrant soaps and a relaxing atmosphere. When I contacted her about the project, I received an almost immediate response. She was as excited as I was and welcomed me into her studio on a busy production day. Saipua was the ideal first shoot. The space was beautiful and bustling with activity. I got a sense of all the hands that work together in the studio, including Sarah's staff and interns. Nicolette Owen (of Nicolette Camille) was also there helping out and animatedly discussing an upcoming trip to Iceland with Sarah. It was amazing to see the beauty created right before my eyes— artful arrangements brought to life from bunches of flowers. One of the best parts was seeking out the hidden treasures and trinkets in the studio. I can recall a jar of everyday rubber bands, sitting next to two tiny vases on a shelf, that took on the

9

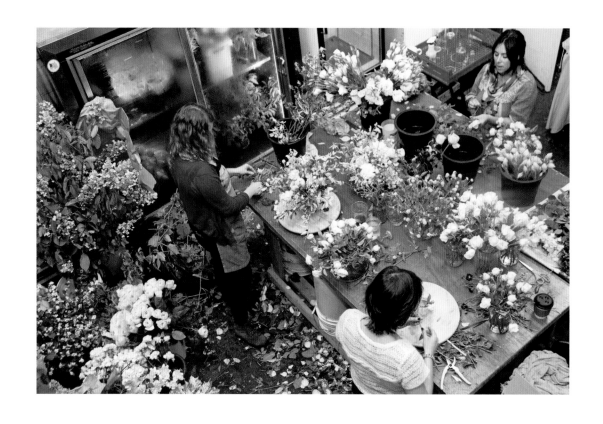

qualities of a piece of art. Sarah encouraged me to go upstairs for another perspective. Now, whenever possible, I try to get a photo from above the action—it has become one of my favorite shots. After the success of the shoot, I knew this project was special, and that there were so many more makers to meet.

Another memorable shoot from early in the project was my visit to Mast Brothers Chocolate. I spent the morning in their space and was able to follow the entire chocolate-making process, "from bean to bar." It was inspiring to see people who genuinely cared about the products they were making. Both brothers talked passionately about sourcing their beans, as well as trying to achieve a family-type work environment. They pride themselves on sitting down to share a staff lunch together every day, as a family, at a large table in the front of their store. On the day I was visiting, they invited me to join; the meal was cooked in-house in the same oven used to roast their cacao beans.

Visiting the makers, witnessing their craft, also brings me back to my childhood. Growing up, I was surrounded by makers, without really knowing it at the time. My grandmother was a seamstress, as well as a master crocheter. My most vivid memories involve her sitting in her chair, surrounded by yarn, crochet needle in hand, making blanket after blanket. My mother is also a maker, always crafting, gardening, or cooking. And my father, he is constantly building or fixing something, an engineer by profession. I still remember the wooden dollhouse he made me by hand, as well as the swing set in our yard. He had a woodshop in a garage that he also built at our old house. Fond memories come flooding back when I observe many of the makers in this book.

Somewhere between these formative years and my adult life, as a society we seem to have lost the connection with our makers. This is particularly true in a big city, which is why I wanted to start this project where I live, in Brooklyn, New York. Surrounded by so many busy people just trying to make it through the day (trying to pay the rent), I wanted to be able to connect with those around me in a tactile way. Through this project, I have seen that we are, in fact, yearning to move back to a time when we knew our makers. Brooklyn is a diverse community filled with creative, motivated individuals, who are championing a return to craftsmanship and artisanal making, who are concerned about where things come from. Witnessing this firsthand is exhilarating.

While I was in their studios, the makers invited me to be a part of what they were doing. I was incredibly moved by the care the makers take in their processes; the work is as much about the process as the product. I discovered what inspired them, saw their works in progress, and sampled their goods. I can still taste the creamy coolness of the avocado *paleta* from Fany Gerson (of La Newyorkina), and recall the spicy kick of the mustard spice cookie from Ovenly. I also remember coming home to a bag of whiskey and moonshine delivered to my doorstep, thanks to Kings County Distillery. I hope you enjoy this journey into the studios of the Brooklyn makers as much as I did.

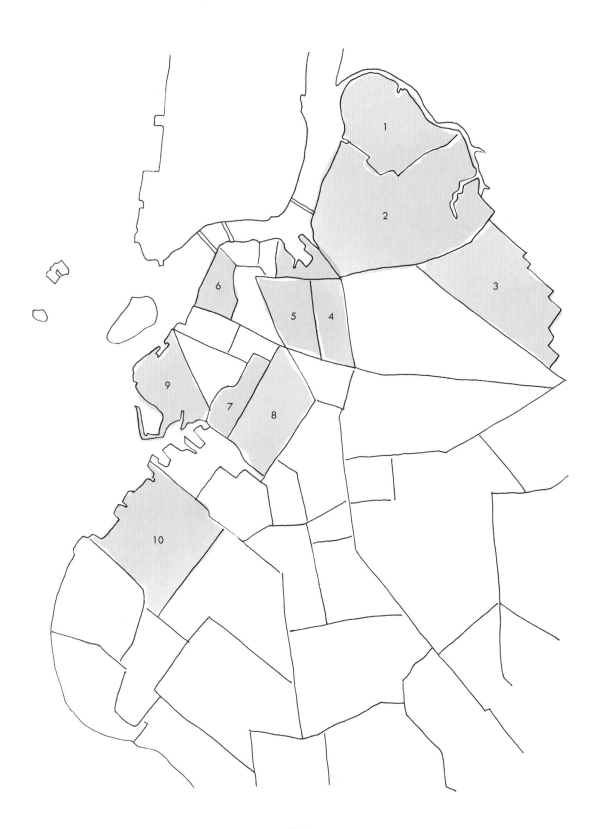

MAKERS MAP

North Brooklyn

1—Greenpoint
Clam Lab
hOmE
Bellocq Tea Atelier
Odette New York
Fay Andrada
Nicolette Camille
Wiksten
MCMC Fragrances
Paulie Gee's

2—Williamsburg
Erin Considine
Fleabags
Mast Brothers Chocolate
Morris Kitchen
Shabd
Blue Bottle Coffee

3—Bushwick
Lady Grey Jewelry
Kings County Distillery

South Brooklyn

4—Clinton Hill
Joya Studio

5—Fort Greene
Lena Corwin

6—Brooklyn Heights
The Jewels of New York

7—Gowanus
Four & Twenty Blackbirds
Lotta Jansdotter

8—Park Slope
Reverie

9—Red Hook
Ovenly
PELLE
Saipua
Elephant Ceramics

10—Sunset Park
Liddabit Sweets
La Newyorkina
Robicelli's

NORTH

North Brooklyn is made up of the Greenpoint, Williamsburg, and Bushwick neighborhoods. Previously a booming industrial area, it has evolved into a creative hub, as large, light-filled factory spaces have been transformed into studios. Connected by the Williamsburg Bridge (constructed in 1903) to Manhattan's equally fashionable Lower East Side, North Brooklyn is primarily served by the L train line, which runs east to west from the far reaches of Bushwick and beyond to Bedford Avenue (Williamsburg's main street) and into the city.

BROOKLYN

North Brooklyn provides the perfect grounds for the borough's celebrated makers, including Paulie Gee's pizza and Kings County Distillery, New York City's first legal distillery, as well as the eclectic Dobbin Mews studio complex (with a florist, perfumer, and jewelers). In addition to the burgeoning creative community, the area is also home to generations of families, and the local businesses they run; here, new and old thrive side by side.

Clam Lab

who	**Clair Catillaz**
location	**Greenpoint**
from	**New York**
years in Brooklyn	**since 2006**

Clam Lab is located in the massive Greenpoint Manufacturing and Design Center building at the very end of Manhattan Avenue (Greenpoint's main street). The industrial structure sits along the Newtown Creek, dividing Brooklyn and Queens. Occupying a small corner of a loft space shared with over a dozen other ceramic artists, Clair Catillaz has created a cozy nook for Clam Lab, taking advantage of the natural light from the window (and the view of the Pulaski Bridge, an active drawbridge).

Clair first became interested in ceramics when she was just twelve years old, while taking classes with her mom—and has been playing with clay ever since. For Clam Lab, Clair produces bowls, mugs, teapots, kitchen tools, and ovenware and handcrafts everything on a manual kick wheel. Using stoneware and porcelain clays, she finishes each item with hand-mixed, food-safe glazes, making pieces that can last generations. She is inspired by midcentury ceramicists such as Russel Wright and Edith Heath, evident in the smooth, clean lines of her wares. Working with her hands, Clair gains satisfaction from the tangible results of a day's work and from producing objects that are useful as well as beautiful. There is great value in eating or drinking from a handmade item; as Clair notes, it "feels good, and makes everything taste better."

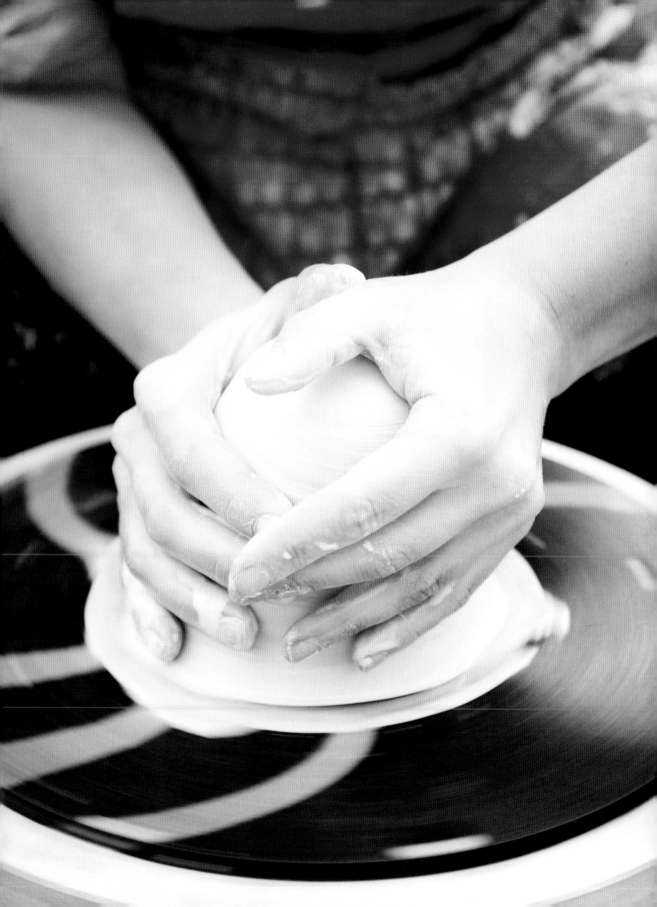

Working in her Greenpoint studio, a comfortable corner of a much larger space shared with several ceramic artists, Clair perfects a teapot, showcases one-of-a-kind glazed mugs, and shares some of her essential tools.

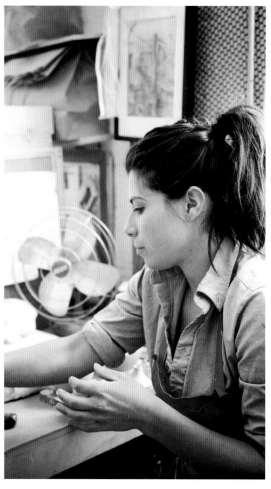

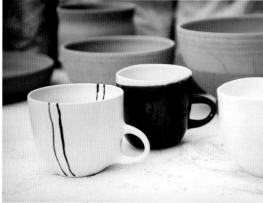

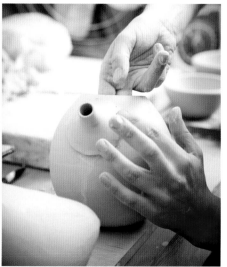

Describe your toolkit in detail. I have a ton of tools, but find myself almost exclusively using the same six to ten items for everything. This includes: sea sponges of various sizes and densities; metal and rubber ribs for smoothing and compressing surfaces; a standard trimming tool, as sharp as possible; a needle tool, which always gets lost; a thin wire for slicing clay; a smooth, tapered wooden stick, for adding handles and poking holes; loose X-acto blades, for precise cuts (these always turn up in my recycled clay); good Japanese watercolor brushes; and a quiet fan and dry-cleaning plastic, to control moisture levels.

Where do you source the materials used in your work? Once upon a time, Brooklyn was known for its red clay, but my main supplier is in New Jersey. Almost everything comes from somewhere on the East Coast.

What is the most satisfying part of your making process? Putting together a perfectly leather-hard teapot. So much of working with clay is about timing. I like to play with composition when everything is a little too wet. Most potters agree that this is the stage when clay looks the best.

What is the most significant investment you've made in your business? I just bought a kiln!

Do you barter with or purchase from other Brooklyn makers? Absolutely. In addition to other ceramics work, I have a few beautiful custom-made dresses and a quilt on the way. I trust people that make stuff, because we share the same sense of pride in what we do.

19

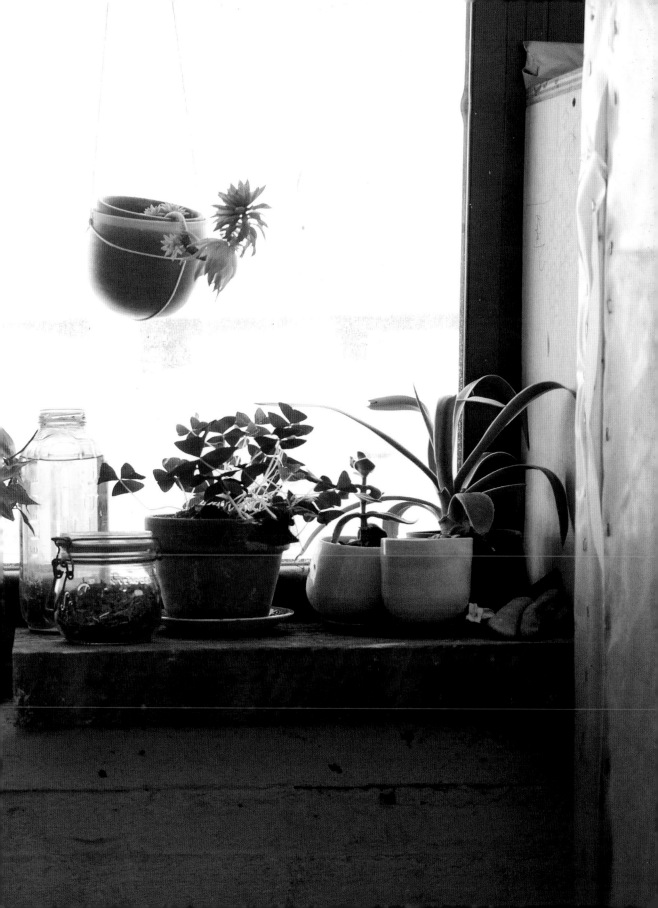

hOmE

who	**Evan and Oliver Haslegrave**
location	**Greenpoint**
from	**Connecticut**
years in Brooklyn	**since 2001**

Brothers Evan and Oliver Haslegrave grew up as third-generation builders, creating alongside their father in Connecticut. Before going into business together, Oliver worked as a literary editor in New York City and Evan as a specialized handyman. When Evan's business began to boom, Oliver joined him. They formed hOmE, a building and design company named for their close family (hOmE is an anagram of Evan, Oliver, and their younger sisters, Hadley and Morgan) and their trade. A combination staircase/bookshelf they designed for a client in Brooklyn led to the renovation of the popular East Village bar Elsa, which solidified their distinct perspective (for Elsa, they used salvaged wood and disguised a beer tap inside a vintage sewing machine).

The brothers enjoy combing flea markets and salvage yards (such as Brimfield in Massachusetts, Elephant's Trunk in Connecticut, and Build It Green in Queens) for interesting materials to reuse in the furniture and interiors they create. They are masters at repurposing old objects into new ideas, like the lighting fixture they were making out of an old croquet set shown in these photographs. Evan and Oliver often design and build out spaces for other Brooklyn-based businesses, including the Manhattan Inn and Paulie Gee's, both in their Greenpoint neighborhood. They have also worked with Kings County Distillery, trading furniture for a barrel of bourbon, and are designing their new distillery in the Brooklyn Navy Yard.

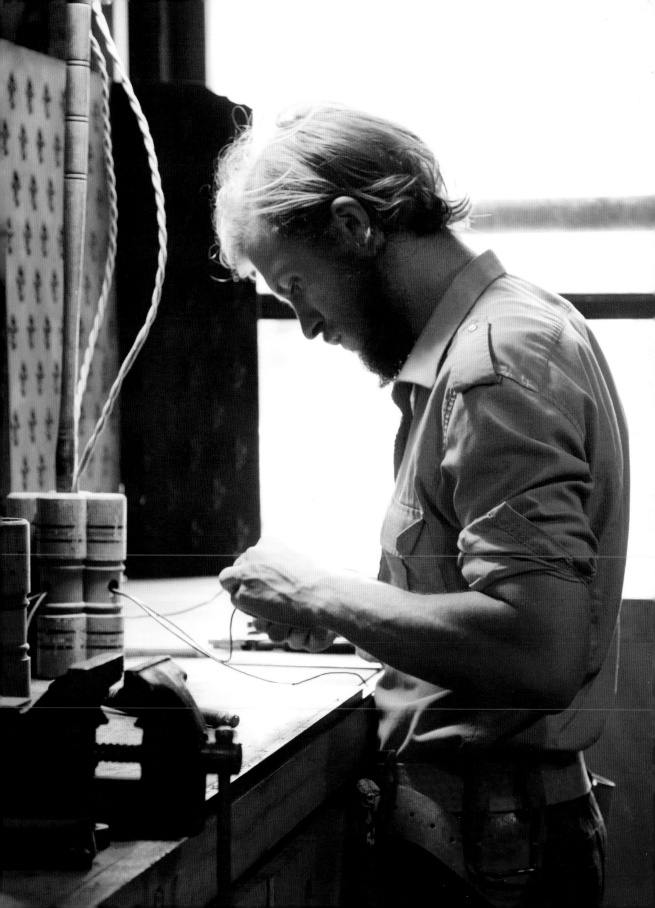

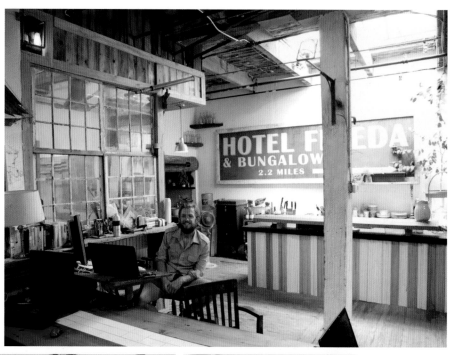

The Haslegraves live and work in an eclectic, light-filled studio made up of discarded windows and doors, books and tools, and other artifacts from their flea market finds. The brothers give each piece a new life, such as the croquet mallet lighting fixture shown in process here.

Bellocq Tea Atelier

who	Heidi Johannsen Stewart, Michael Shannon, and Scott Stewart
location	Greenpoint
from	Heidi: New York
	Michael: Massachusetts
years in Brooklyn	Heidi: since 2001
	Michael: since 2011

Bellocq was founded by Heidi Johannsen Stewart, Michael Shannon, and Scott Stewart in 2010. The friends formed the studio to share their interests in traditional artisan work and love of fine tea. The company began as a year-long pop-up shop on London's fashionable King's Road in Chelsea, but has since found its home near the East River in industrial Greenpoint.

To make their unique blends, Bellocq starts with pure, high-quality teas from around the world (including China, Japan, India, Sri Lanka, and Taiwan).

These single-estate collections are then combined with special blends of herbs, flowers, and other botanicals to create new flavor profiles. The partners draw from their experiences, especially their travels, to form the shop's welcoming and enlightening environment. Bellocq's decor of dark, rich walls and warm woods, punctuated by bright yellow canisters, contains an extraordinary mix of found objects, antique teapots, dried flowers, and various other discoveries. The partners' stories of exotic lands add to the intrigue of the space and the tea.

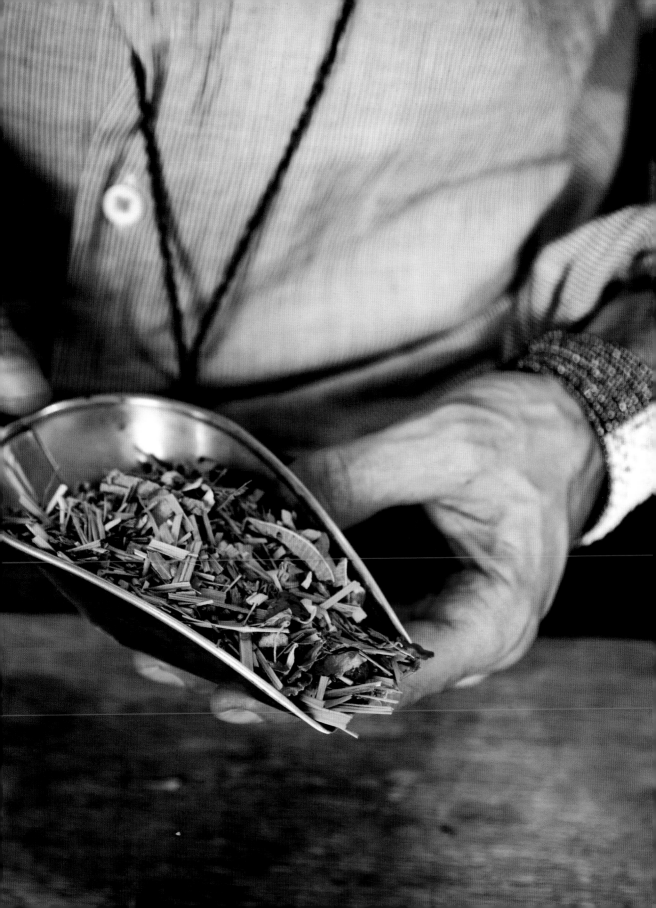

How has Brooklyn influenced your work?
HEIDI: There is a certain sense of liberation working
in Brooklyn. The "rules" aren't quite as fixed.
I'm keen to experiment a bit more. MICHAEL: It's
that entrepreneurial spirit again. There's also
nothing more satisfying than being in a community
of like-minded people who are willing to take
creative chances.

What do you see outside your shop window?
HEIDI: A narrow slice of the East River and the tip of
the Empire State Building.

Describe a typical day at work.
MICHAEL: It changes day to day. On a good day,
we talk about new inspirations and create for
the rest of the time. And on a very good day, we slip
into conversations about the things that inspire us
most: illuminated moments, places, and environments
we'd like to revisit through our work.

**What is the most satisfying part of your
making process?** MICHAEL: Teas have the ability to
make people feel and remember beautiful moments
of their lives. Flavor and smell can touch the senses
in the most unexpected ways. It's not something
that we understood when we started, although it's
now one of the things we are most proud of.

**What is your favorite product that you
make?** MICHAEL: It would have to be the newest
one because that is where the mystery lies.
Flavors have a way of creating their own situations.
And while we spend a tremendous amount of
time developing our teas, in the end, the excitement
of working with nature always wins.

What's your strategy for creative block?
MICHAEL: I always return to nature to see the
things that are bigger than me. There's something
so miraculous about a seed the size of a pinhead
turning into a colossal plant that any feeling of
being overwhelmed vanishes.

*All questions answered by Heidi Johannsen
Stewart and Michael Shannon

The excitement of working with nature always wins.

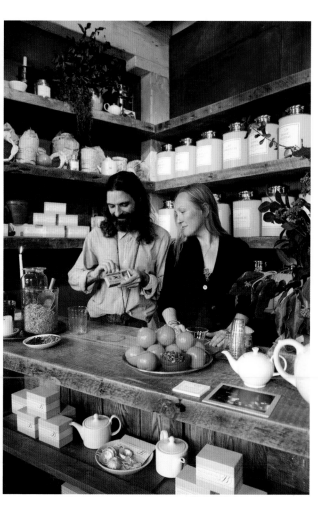

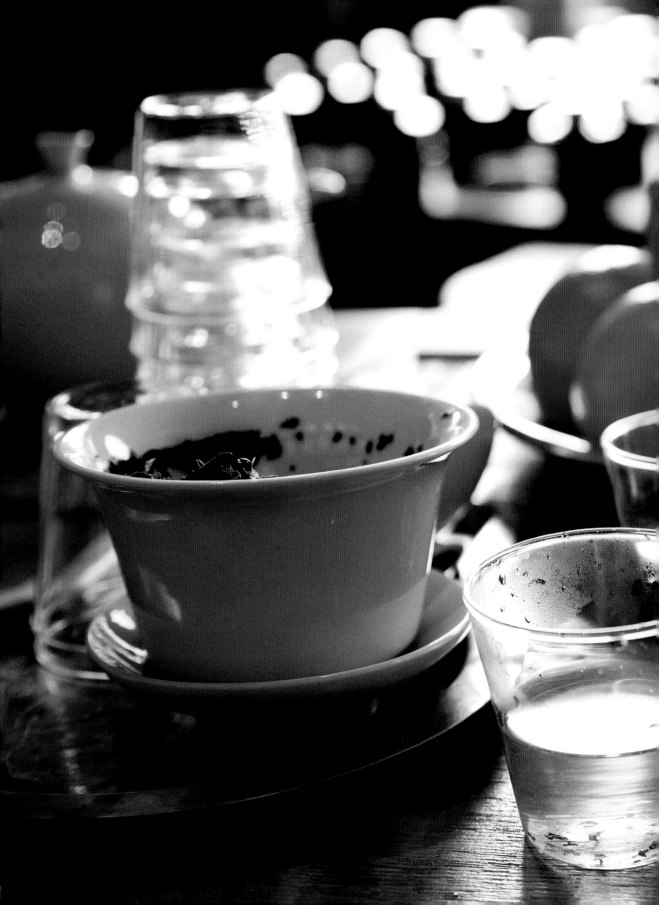

Odette New York

who	**Jennifer Sarkilahti**
location	**Greenpoint, Dobbin Mews**
from	**Virginia**
years in Brooklyn	**since 2007**

Jennifer Sarkilahti describes her jewelry line, Odette New York, as "classic with a slightly bohemian touch." Drawing from her travels (recently to Bali, Morocco, Turkey, and Greece) and the metropolis in which she lives, her work is inspired by organic and industrial shapes, primitive forms, natural specimens, and uncommon artifacts. With a background in fine art (including painting, as well as photography, sculpture, and graphic design), Jennifer translates pencil sketches into small sculpture-like wax forms, using ancient and modern carving techniques. Although as a jeweler she is primarily self-taught, she has always had a passion for making things, a trait she traces to her childhood when she would channel her wild imagination into handmade goods.

Jennifer is also motivated by working alongside other makers as part of Greenpoint's Dobbin Mews studio collective. Home to many of the artists featured here, the creative complex, located near McCarren Park, recalls the site's history as a horse stable (*dobbin* is a workhorse and *mews* is a group of stables). Currently, Jennifer shares a space with Anne McClain of MCMC Fragrances and Emily Hirsch of Talon; previously she shared a studio with Jenny Gordy of Wiksten. Jennifer's work is energized by the high-caliber talent and boundless ambition of those around her in Brooklyn. She notes, "It feels like I'm riding with a current. I've been influenced to make more here than anywhere I've lived."

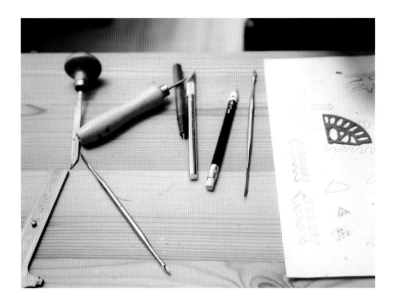

What brought you to Brooklyn? I was nineteen years old when I came to New York City for the first time and I knew I would live here someday. It was the Fourth of July and the city was buzzing with what felt like an infinite amount of energy.

What did you look for in a studio space? Two things: good natural light for carving tiny items out of wax and some cool, creative people to be surrounded by. I hit the nail on the head with both.

How do you get to work? Usually I walk, it's just a short stroll through McCarren Park.

Where do you source the materials used in your work? My production is small and local so that everything can be made with special attention. I make all of my wax models at my studio, and I have a personal relationship with my casting house across the river in Manhattan so that I can oversee every part of the process.

What is the most satisfying part of your making process? When I finish carving a wax and send it off to my casting house for the first proof. Seeing how the wax translates into metal can be exhilarating, sometimes it works and sometimes it doesn't. There is a lot of editing during this stage so when a design makes the cut, it can be very satisfying.

What is your favorite product that you make? I'll always have a soft spot for my first wax carving, which was a flat, somewhat crude, hand-drawn etching of a large jellyfish with tentacles.

How did you come up with the name of your business? I've always loved the name Odette, a character in both *Swan Lake* and Proust's *Swann's Way*.

If not in Brooklyn where would you live? One day, I'd like to spend time near the ocean, being still and watching the waves.

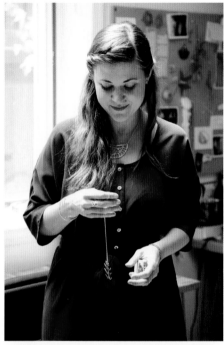

Jennifer achieves her jewelry's signature hand-textured surfaces through a detailed and multi-layered process, involving sketching, wax carving, casting, polishing, and much more.

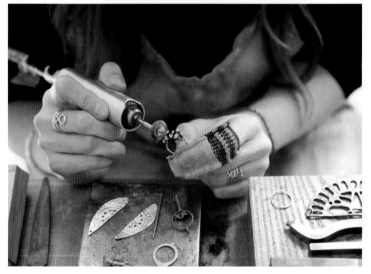

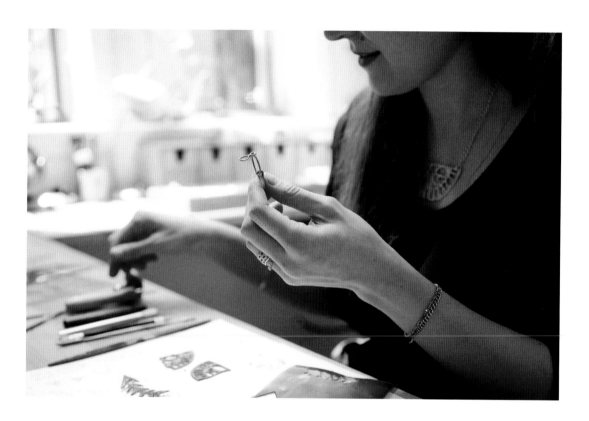

It feels like I'm riding with a current.
I've been influenced to make
more here than anywhere I've lived.

Fay Andrada

who	**Fay Andrada**
location	**Greenpoint, Dobbin Mews**
from	**Connecticut**
years in Brooklyn	**since 2001, off and on**

Illustrator and jewelry designer Fay Andrada has lived in and out of Brooklyn over the past twelve years—something always brings her back. Most recently, she returned from Portland, Maine, following her studies in metalsmithing at Maine College of Art. While looking for a space to start her jewelry business, Fay was inspired by the meaningful and personal creations of the makers at Dobbin Mews. She joined the courtyard complex and now shares a space with college friend and floral designer Nicolette Owen (of Nicolette Camille). Fay has found her studiomate to be invaluable to her work. Despite their differing styles, they provide continual support for each other (as well as a critical eye), sharing inspirations, bouncing ideas back and forth, and sometimes sipping champagne together in the afternoon.

In the studio, Fay thrives on problem solving—sitting down with a limited amount of material (including metal scraps and even failed experiments) to produce a piece from start to finish. Regarding her process, Fay states, "It's like cooking, utilitarian and not necessarily precise." She embraces imperfections in her designs, using hammers, files, and a flame to create simple, statement-making jewelry out of sheets of metal.

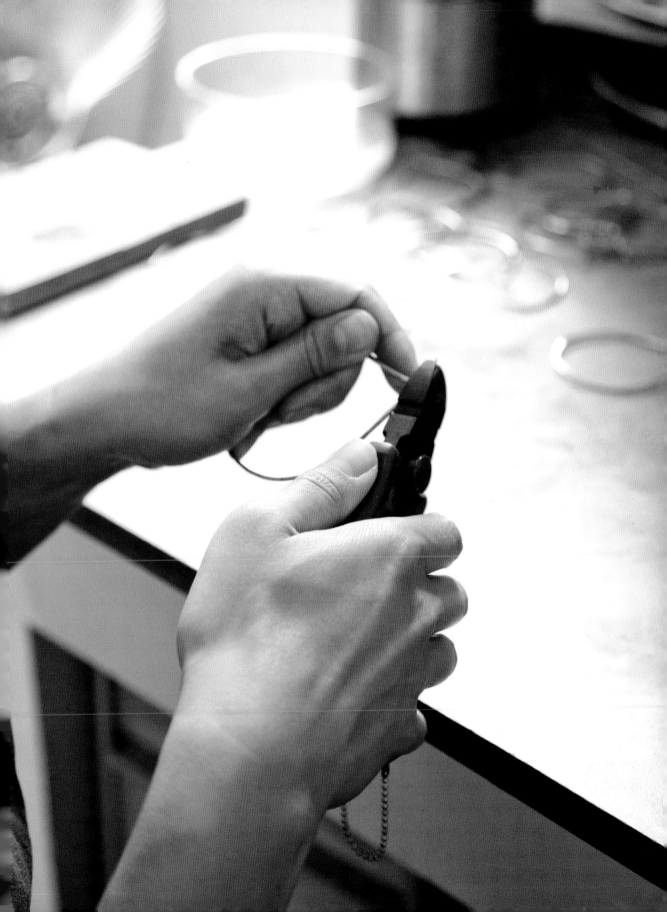

How long have you lived in Brooklyn?
It adds up to about ten years, six apartments,
and three neighborhoods. I tried leaving a couple
of times. I lived in London for two years, came
back, and later spent a year and a half in Portland,
Maine—and then came back again.

How do you get to work? I go through
phases of walking, driving, cycling, and taking the
bus. My dog, the weather, the amount of stuff
I need to schlep, my studiomate's schedule, the b48
bus schedule, and shoes all influence the decision.

Describe your toolkit in detail. My toolkit
is highlighted by two things: first, a birch tree stump
upon which my bench vise sits. A lot of metalsmiths
have hardware bolted onto tree stumps, but I have
the most beautiful stump thanks to my studiomate,
the florist. Second, a four-square-foot iron plank
that my landlord found and made into a table
for me. It took the strength of two large men to lift
it. It's basically an entire table's worth of anvil.

**What is the most significant investment
you've made in your business?** The studio space is
such a luxury. I still can't believe that I can go there
every day and earn a living.

**Do you barter with or purchase from other
Brooklyn makers?** Trading is my favorite. I do some
of my best work when I know who will be wearing it.

**How do you treat yourself after you reach
a creative milestone?** Champagne. Always.

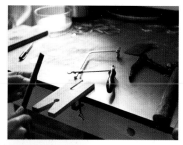

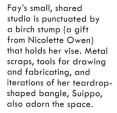

Fay's small, shared
studio is punctuated by
a birch stump (a gift
from Nicolette Owen)
that holds her vise. Metal
scraps, tools for drawing
and fabricating, and
iterations of her teardrop-
shaped bangle, Suippo,
also adorn the space.

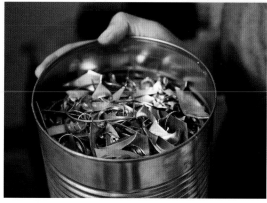

Nicolette Camille

who	**Nicolette Owen**
location	**Greenpoint, Dobbin Mews**
from	**New York**
years in Brooklyn	**since 2000**

Nicolette Owen is a floral designer and owner of the flower studio Nicolette Camille. She grew up in the gardens of her mother and grandmother, and is inspired by both cultivated and wild landscapes. A master at combining seasonal blooms, along with the occasional special cutting from the garden of her Williamsburg apartment, she creates beautiful arrangements for magazines and weddings and other events. Nicolette began her business from home, using the kitchen and living room as her flower studio. When the work literally outgrew the apartment, she moved into the creative Dobbin Mews complex, where she shares a space with metalsmith and jewelry designer Fay Andrada.

When she's not creating arrangements for her own clients, she collaborates with fellow floral designer and friend Sarah Ryhanen of Saipua. The two also combine efforts to teach one-day floral workshops known as the Little Flower School, where they celebrate the bounty of the season and reveal techniques for selecting flowers, blending colors and textures, and building stunning centerpieces. The classes are held in their Brooklyn studios, as well as on the road (they have taught on the West Coast and now have their hopes set on Europe). The partnership and school provide Nicolette with support and continuous motivation.

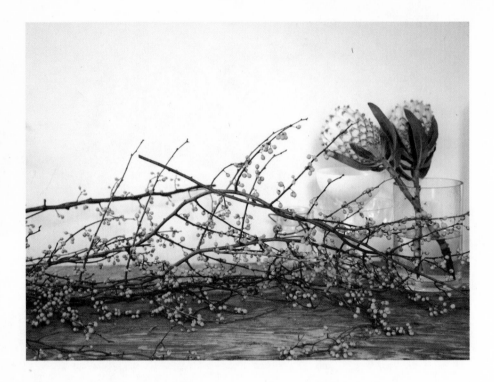

What do you see outside your studio window? Brooklyn's most abundant fig tree (in the Dobbin Mews courtyard).

Describe your toolkit in detail. My clippers and sheath (always on my hip), scissors, ribbon scissors, rose stripper, lopers, leather gloves, waterproof tape, floral tape, flower frogs, pins, safety pins, rubber bands, glue, tarps, torch lighters, Band-Aids (I'm accident prone), masking tape, spray bottle, towels, tarps.

What is the most satisfying part of your making process? I enjoy the fleeting quality of flowers; putting all of your creative energy into making something beautiful, then handing it off for others to enjoy.

What is the most significant investment you've made in your business? Probably getting a bigger space. Also, my crew of freelancers has changed my life! I always think I can do everything myself, and having some talented helpers has been a revelation.

If Brooklyn had a flower, what would it be? I think it should be the hellebore. This lovely plant blooms throughout the winter—even through the snow. It's the dainty promise of spring that we all need to get us through the winter.

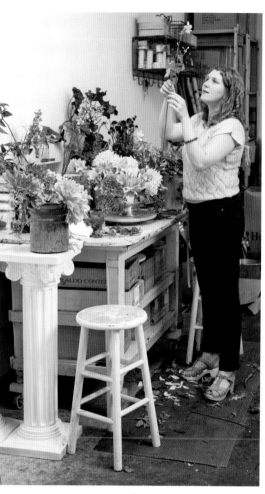

Inspiration abounds in
Nicolette's flower studio,
from wires and ribbons and
other assembled objects
to in-process arrangements,
haphazard vignettes,
and even cast-off cuttings.

45

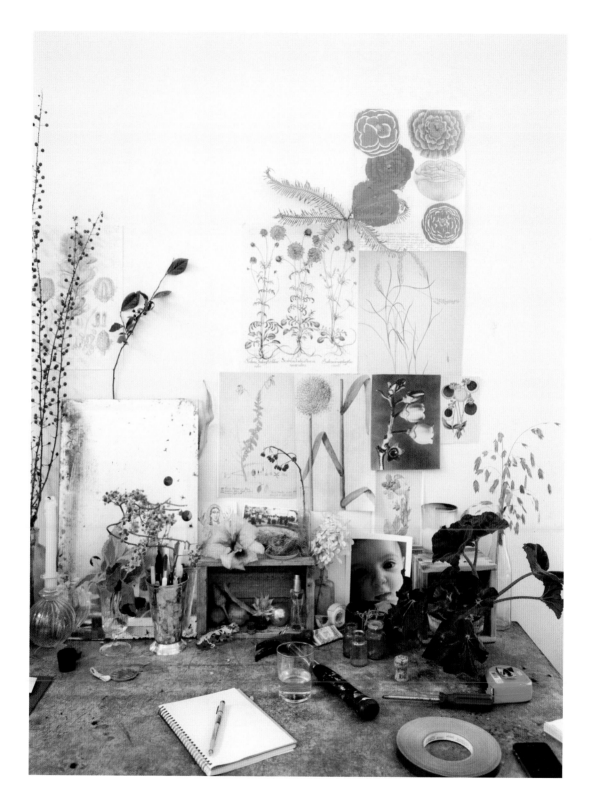

Wiksten

who	Jenny Gordy
location	Greenpoint, Dobbin Mews
from	Kansas
years in Brooklyn	from 2003–5 and 2009–11

Jenny Gordy is the designer of Wiksten, a clothing line named for the Swedish grandparents who inspired her to create (her grandfather made jewelry and furniture and her grandmother crafted clothing and quilts). Wiksten embodies Jenny's heritage with cozy Scandinavian simplicity, combining traditional elements with special details. She hand makes her designs in natural linen, cotton, and silk and is often drawn to striped, plaid, and ikat patterns for classic silhouettes.

Jenny first moved to New York to attend the Fashion Institute of Technology. Following her studies, she relocated to Kansas, then returned to the city to establish her own business. This allowed her to work at a fulfilling pace while maintaining control of her artistic destiny. Roused by the creative energy and innovative dress of the people of Brooklyn, Jenny also credits her studiomates at Dobbin Mews for daily inspiration. Working in close vicinity to other makers enables collaboration and constant motivation. In particular, she views women makers, such as Jennifer Parry Dodge of Ermie in California and Jennifer Sarkilahti of Odette, among many others, as the muses for her elegantly casual designs. Although she recently moved again, the relationships she forged in the city, especially with those she worked alongside at Dobbin Mews, continue to fuel Wiksten.

Describe your toolkit in detail. Metal dressmaker's rulers and French curves, a C-Thru ruler, pencils, butcher paper, fine point Sharpies in all colors for grading patterns, four pairs of scissors for different tasks, two sewing machines, an iron and ironing board, a sleeve ironing board, a sewing slide ruler, pins, thread, a thimble, and a seam ripper. It's not a very portable job.

What is the best part of working with your hands? Getting into a rhythm and becoming completely absorbed in the process, oblivious to any thoughts or concerns other than what I'm doing.

What is the most satisfying part of your making process? I love the process of sketching and constructing designs, and there's nothing better than when something works. When I hang a completed sample on the garment rack, I feel a real glow of pride. But the best is seeing it all come together into a completed vision during a photo shoot.

When I hang a completed
sample on the garment rack,
I feel a real glow of pride.

MCMC Fragrances

who	**Anne McClain**
location	**Greenpoint**
from	**Rhode Island and Japan**
years in Brooklyn	**since 2004**

Before moving to Brooklyn, Anne McClain grew up in Rhode Island and Japan. Inspired by the creativity in the borough, she began to pursue her passion of perfumery. In 2009, she ventured to southern France to study at the Grasse Institute of Perfumery, and upon returning to Brooklyn, she started formulating and bottling her own line of fragrances under the name MCMC Fragrances. Anne began her business working out of a small studio in the back of her top-floor apartment (where these photographs were taken). She has since relocated MCMC to Dobbin Mews, where she shares a studio with jewelers Jennifer Sarkilahti of Odette and Emily Hirsch of Talon.

Each of Anne's fragrances embraces the memory of a personal experience, which is translated into a scent. Her Maui perfume, for example, references a summer trip to Hawaii and embodies what she describes as the essence of freedom with a laid-back vibe. It contains top notes of young ginger and star anise and a heart of frangipani, tuberose, and green bamboo, wrapped in a light salty breeze. Hunter, with tobacco absolute, bourbon vanilla, and fir balsam, recalls a longtime friend and woodsman who built maple sugar cabins in Vermont. Noble is filled with the scents of a four-month trip to Nepal. And Maine is a love story.

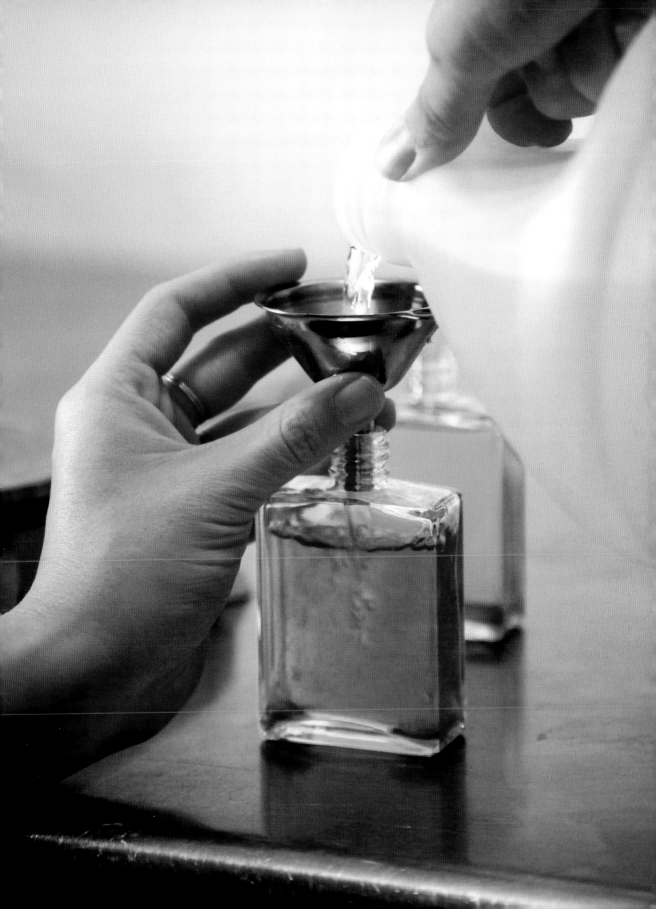

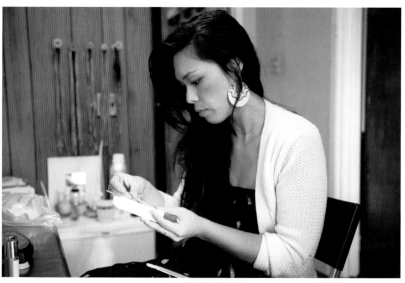

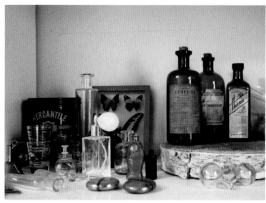

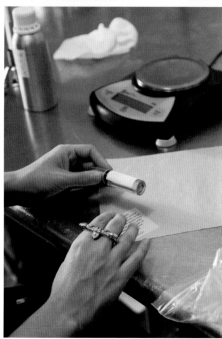

Anne's precise, yet personal approach to each fragrance is perfectly at home in her studio, which strikes a balance between laboratory and collector's cabinet. Her rooftop greenhouse provides respite from the all-consuming work and the bustling city.

How has Brooklyn influenced your work?
Had I not been living here, I don't think I would've
had the courage to start a perfume company. Being
surrounded by so many creative entrepreneurial
people allowed me to visualize myself doing it as well.

**What is the most satisfying part of your
making process?** What I like most about the process
is how meditative it is. Making perfume requires
lots of concentration and attention to detail. The
difference between drafts can be really subtle and
when I'm in the middle of making a new fragrance,
I have to focus on smelling something over and over,
and I feel transported.

How do you develop a scent? When
I have an idea for a scent, I first get it on paper to
test if the various ingredients will go well together.
Sometimes, I associate colors, words, or images.
Always, I have several key natural ingredients
that form the backbone of the fragrance. I have a
fairly large memory bank of scents from studying
at Grasse, where I learned to memorize about five
hundred individual ingredients. I can usually recall
how something smells (like peach, marshmallow, iris,
or Virginia cedarwood) in my mind. Then, I begin
making trials, filling out the details and rounding out
the fragrance with accessory notes. The number
of trials can vary from a few dozen to over a hundred
before I hit upon what will be the final formula.

What scent do you wear? Noble and Love.

Paulie Gee's

who **Paulie Gee**
location **Greenpoint**
from **Brooklyn, New York**

Paulie Gee grew up in Brooklyn and currently lives in New Jersey. When he left a career as an IT consultant to start his pizzeria, he wanted to open his restaurant in an up-and-coming neighborhood with a great sense of community. North Brooklyn provides the adventurous spirit he was looking for. A pioneer of the emerging food scene in Greenpoint, Paulie Gee's attracts pizza lovers from all over the city.

Paulie perfected his pizza-making technique in the wood-burning oven he built in his backyard. He is known for his distinct flavor combinations as well as the names he gives to his pies. The Hellboy, for example, is a mouthwatering combination of sweet and savory, featuring Fior di Latte,

Italian tomatoes, Berkshire sopressata picante, Parmigiano-Reggiano, and Brooklyn purveyor Mike's Hot Honey. Paulie also has a pizza that pays tribute to the neighborhood: the Greenpointer, with Fior di Latte, baby arugula, olive oil, fresh lemon juice, and shaved Parmigiano-Reggiano.

Paulie Gee's epitomizes Brooklyn character. Paulie is an ardent supporter of local craft; he hired the Haslegrave brothers from hOmE to design his restaurant and uses and sells baked goods from Ovenly and other area makers. He strives to make everyone feel at home, greeting every table every night. This, along with the amazing pizza, is why Paulie Gee's has become a staple in Greenpoint dining.

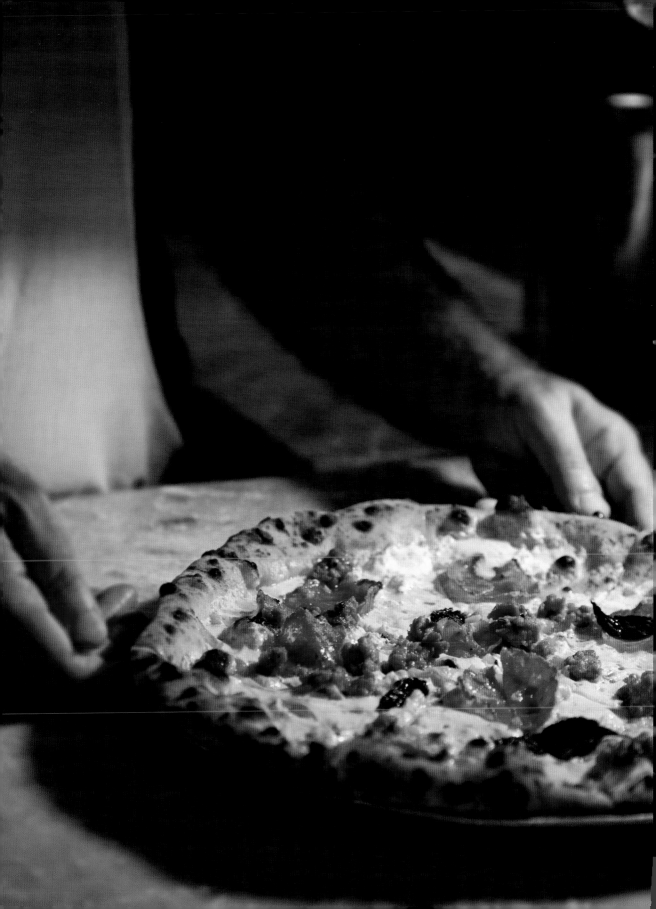

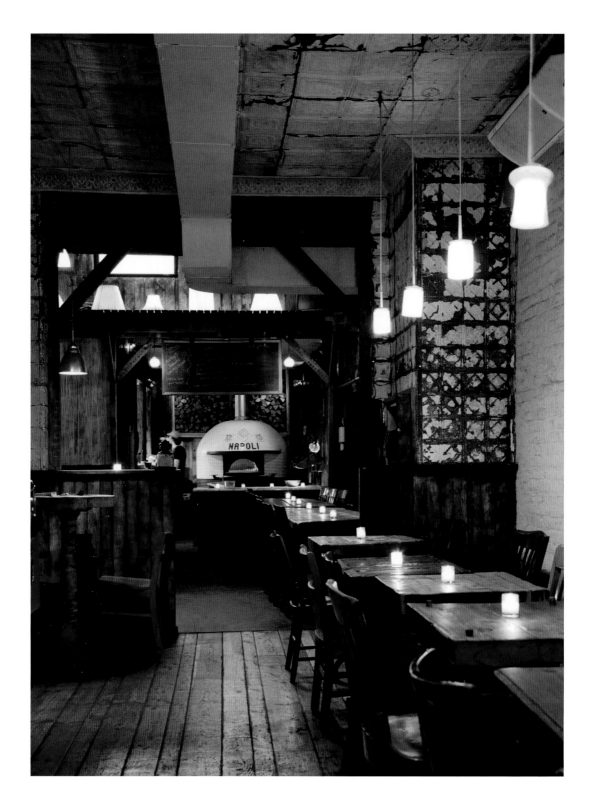

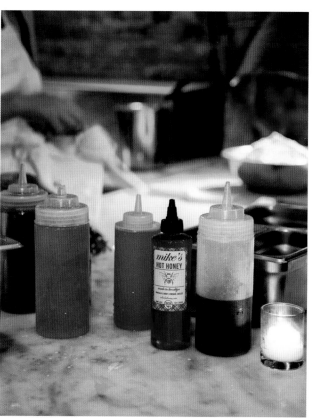

Locally revered Paulie Gee's pizzeria features an inviting decor, as designed by hOmE, complete with a wood-burning oven, and the very best pies.

Erin Considine

who	**Erin Considine**
location	**Williamsburg**
from	**Maryland and Missouri**
years in Brooklyn	**since 2007**

Erin Considine studied eco-design and sustainable architecture and later fiber arts at Evergreen State College in Washington. Through a summer workshop at Penland School of Crafts in North Carolina, she was introduced to textile techniques in metal. There, working in a jewelry studio for the first time, she was able to merge her passion for sustainability, fibers, and metalwork. She continued her studies in art history and jewelry (in Cortona, Italy, and again at Penland), then moved to Brooklyn to begin her career in the industry assisting other designers.

She was immediately attracted to the challenge and the energy of the creative community in Brooklyn. She attributes being surrounded by other like-minded makers as the motivation to launch her own line. Her collections incorporate metalwork and weaving, which result in a rich, tactile mix of hard and soft (her current collection utilizes Kumihimo, a Japanese braiding technique). She crafts each piece with fibers such as cotton and silk, using natural dyes such as onion skins, turmeric, and hibiscus to achieve beautiful, muted colors. Most of the metal components for her designs are cast out of recycled materials or sourced from vintage dead stock. For one-off projects, she has been known to forage for materials around her neighborhood and pick up discarded metals on the street, turning them into unique (and truly Brooklyn-inspired) jewelry.

At work in her Williamsburg
studio, Erin cooks up natural
dyes for a soft color palette and
tumbles metal in a green pyramid
medium for a matte finish.
Jars of various dye ingredients
and spools of rope and twine line
the shelves of her space.

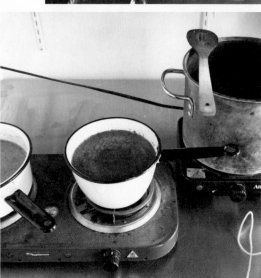

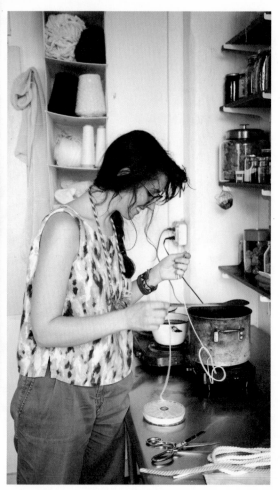

Describe a typical day at work. Because almost everything is made in house, I dance between benchwork and fibers. Some days, I'm cleaning castings, tumbling (a technique for smoothing and polishing rough surfaces on metal), soldering, riveting, and drilling; other days, I'm dyeing, weaving, braiding, crocheting, etc.

Describe your toolkit in detail. So many tools! The typical jeweler's setup: bench, saw, files, Flexshaft and accessories, atmospheric acetylene torch, fifty-pound anvil, hammers, tumbler, pliers, cutters. For the textile portion: Gingher scissors, a Beka loom, crochet hooks, embroidery and bead-stringing needles, knitting needles, Kumihimo disk and spools, natural dye materials and mordants, stainless steel and enamel pots, mason jars, thermometer.

Where do you source the materials used in your work? The majority of the natural dyes (logwood, cochineal, Osage orange, and madder root) are ordered from a supplier in Oregon. These are the most reliable and lightfast dyes suitable for the jewelry. I also hoard onion skins from the CSA share, grocery store, and friends save them for me.

What is the most satisfying part of your making process? Experimenting with new dyes is so satisfying; the outcome is always a happy alchemic surprise.

Where do you get the names for your collections? I've only named my first full concept collection, Immrama from Spring 2011. Immrama are Irish folktales of a hero's journey at sea in search of the otherworld. It's representative of the leap I took after working for others in the New York jewelry industry. It was brewing in me for some time, and I pulled from my past experiences as a maker and collector to create this world.

ERIN CONSIDINE

> Experimenting with new dyes is so satisfying; the outcome is always a happy alchemic surprise.

Fleabags

who	**Shira Entis and Alex Bell**
location	**Williamsburg**
from	**Shira: Massachusetts**
	Alex: Kansas
years in Brooklyn	**Shira: since 2006**
	Alex: since 2010

Shira Entis and Alex Bell met during their first year of college at Brown University. They quickly formed a friendship, but it wasn't until several years later, after each had gained experience in their respective fields (Shira worked as a designer and Alex as a corporate lawyer), that they formed a business together, Fleabags. Fleabags creates utilitarian, stylish totes inspired by vintage luggage and carpenter bags, made with organic materials, vegetable-tanned and repurposed leathers, and flea market finds.

Shira attended graduate school in fashion design at the Savannah College of Art and Design. Alex learned fashion on the job, with training from Shira. Technically, as the lawyer, Alex is the business side of Fleabags, and Shira as the designer represents the creative side, but they are both involved in all aspects of the company. When they decided to start Fleabags, they approached it as a "practice" enterprise—a test to see how they would work together. With the success of their initial bags (the Original Flea), however, the practice business soon became real. Shira and Alex source everything from within the United States, and turn to local vendors as much as possible. They also scour flea markets, estate sales, and eBay for possibilities to incorporate into their designs.

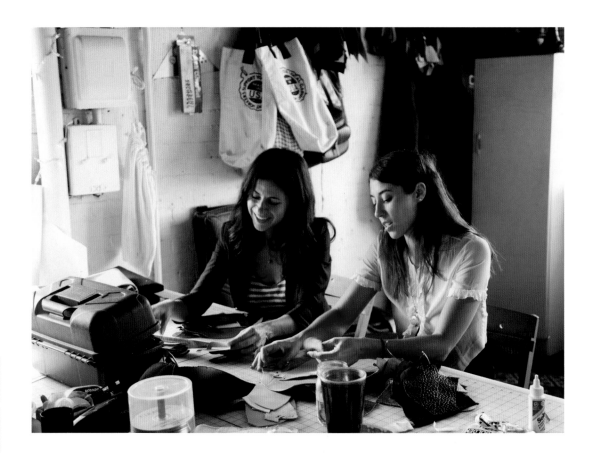

How has Brooklyn influenced your work?
We love the juxtaposition of industrial areas
and quaint neighborhoods in Brooklyn. At times,
Brooklyn feels like a city that hasn't changed
in a hundred years and at other times, it feels very
modern. Both aesthetics influence our designs.

What did you look for in a studio space?
We wanted a space that would feel industrial
and open, with a lot of natural light. We love old
factories because we're reprising an original use.

**What do you see outside your studio
window?** The Brooklyn-Queens Expressway (BQE).
We always know what's going on with traffic.
Also, the Empire State Building and the Chrysler
Building on the horizon.

Describe a typical day at work. We make
coffee on a French press and catch up on any news
when we first get in. The rest of the day entails
emails, factory visits, choosing leathers, making
mock-ups. We take turns making lunch for each other.
Our studio is also our distribution center, so we
do a lot of schlepping of bags, cartons, materials,
etc.—we call it the Fleabags workout.

**What is the best part of working with your
hands?** Feeling like we have complete ownership
over our products. It feels great to take a break
from a mostly cerebral culture and use our physical
selves as well.

**What do you enjoy most about being your
own boss?** Everything. Even the stress is good stress.

Side by side, Shira and
Alex contemplate patterns for
their newest bags. Sketches
for a beach bag and rolls of
weathered leather, among
other inspirations, fill the homey,
industrial Williamsburg loft.

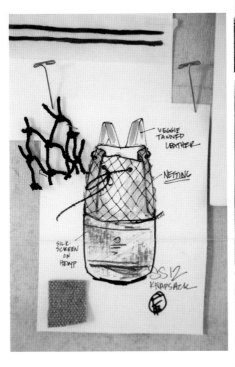

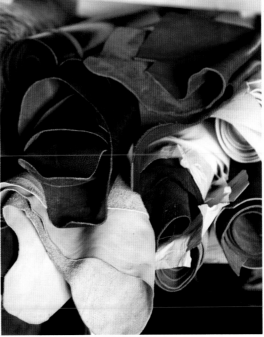

Mast Brothers Chocolate

who	**Rick and Michael Mast**
location	**Williamsburg**
from	**Iowa**
years in Brooklyn	**over ten years**

Brothers Rick and Michael Mast moved to the borough from Iowa a decade ago, Rick as a chef and Michael as a filmmaker. In 2006, in their Brooklyn apartment, they began making chocolate to share with friends and quickly turned their craft into a business. Three years later, they moved from a tiny Greenpoint space to a lofty garage in Williamsburg, and have since expanded their factory and hired a pastry chef to run a test kitchen.

The Mast brothers are committed to sustainable methods of producing and sourcing, buying their beans directly from small organic cacao farmers in the Dominican Republic and Central and South America. They are also dedicated to a hands-on approach in every aspect of their business. They were the first chocolatiers in New York to adopt the artisanal bean-to-bar method. All the bars are at least 70 percent cacao (their chocolate is made entirely of cacao beans and organic sugar) and any additions (such as Maine sea salt, almonds, Stumptown coffee, and serrano peppers) come from purveyors that they trust or know personally.

Each chocolate bar is hand wrapped, first in gold foil and then with a custom paper designed by the Masts and their employees and friends (the papers are printed by Prestone Press in Long Island City, Queens). The brothers foster a sense of community within the company. Every day the entire crew sits down to a family-style meal (often cooked in house) to take a break together. They have recently created their first house blend bar, the Brooklyn Blend, made with all of their favorite beans from around the world and hints of red wine, tobacco, and plum.

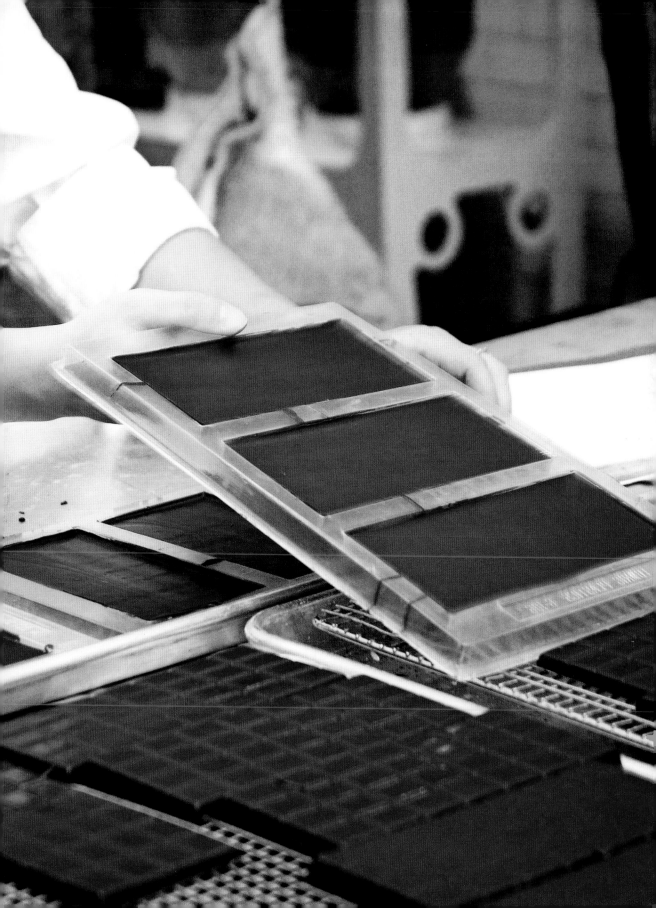

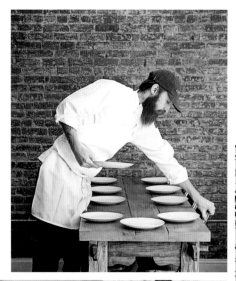

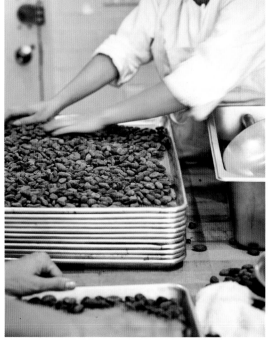

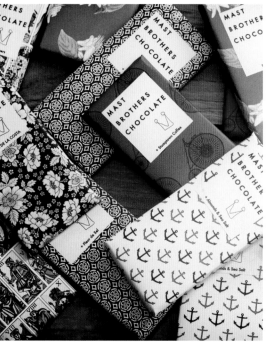

The hands-on approach at Mast Brothers Chocolate extends to roasting the beans in small batches, individually wrapping each bar in gold foil and house-designed paper, and even preparing for the daily company meal.

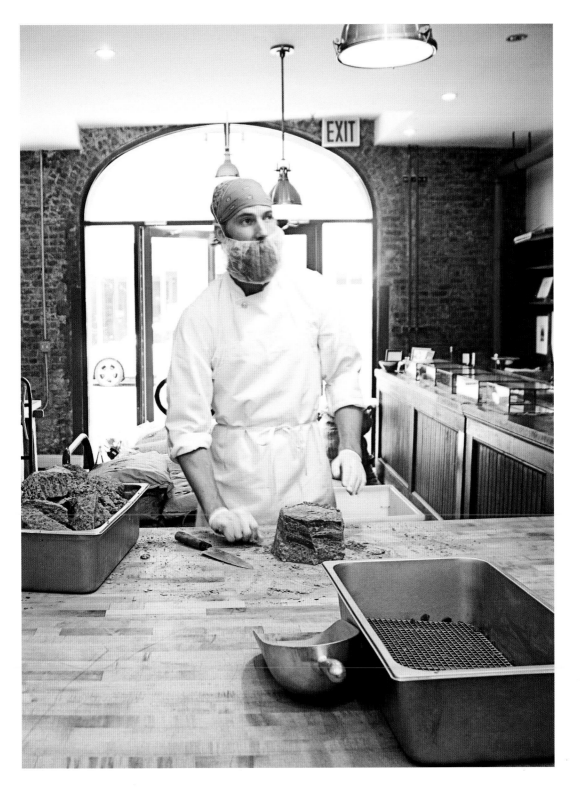

Morris Kitchen

who	**Tyler and Kari Morris**
location	**Williamsburg**
from	**California**
years in Brooklyn	**Tyler: since 2006**
	Kari: since 2005

Tyler and Kari Morris are the brother-and-sister team behind Morris Kitchen, makers of specialty syrups. Tyler is a veteran chef and brings his culinary expertise to their business, and Kari, with a background in the arts, brings her aesthetic eye and artistic approach. Kari also credits her brother with most of her education, and mishaps, in the kitchen. Tyler and Kari love cooking and entertaining and sharing that passion with others. They host a monthly supper club where they invite an eclectic mix of friends and strangers for good food and conversation. It was during one of these evenings that they came up with the idea of creating their own signature syrups to use in food and drink recipes. After several rounds of testing in their Brooklyn kitchen, they arrived at their first product, ginger syrup. They launched the mix at a local food fair and sold out within an hour—Morris Kitchen was a success. They have since added a boiled apple cider syrup to their line, sourcing cider from an orchard in upstate New York, and a preserved lemon syrup with cardamom and pink peppercorn. In addition to seeking out the highest-quality ingredients, the Morrises pride themselves on aesthetics and craft. They package their syrups in amber glass bottles with letterpressed labels, and hand stamp each one with the date it was created.

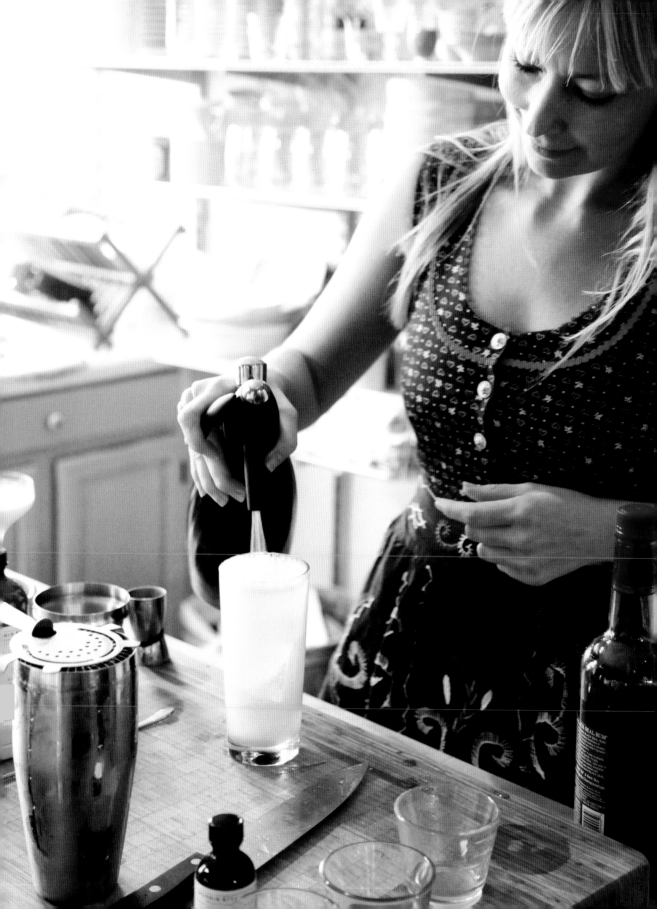

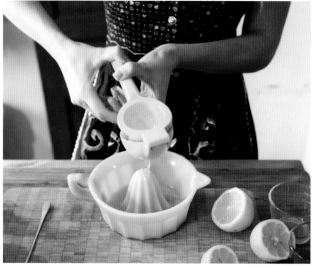

From their Brooklyn
kitchen, Tyler and
Kari process a batch
of their ginger syrup,
finishing off the job with
a signature cocktail.

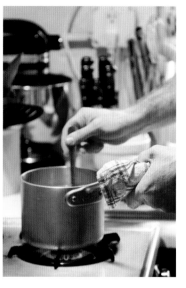

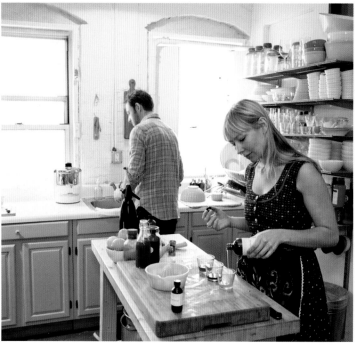

What was the moment when you decided to start your own business? KARI: I have always been a business-minded person. When I was seven, I kept a book of floor plans and hand-drawn business cards for my "architecture business." I like the concept of not only making something but also creating a language and context for that product to exist—the whole package.

Describe a typical day at work. KARI: Juicing, labeling, shipping, bottling, and more juicing.

What is the most satisfying part of your making process? TYLER: The smell of gallons and gallons of ginger syrup boiling away! KARI: Watching it grow, refining the process.

Do you barter with or purchase from other Brooklyn makers? KARI: At the market I always like to barter. Last week, I came home with a loaf of bread, Blue Bottle coffee, truffle salami, and rosemary lard.

What is the best part about working with your sibling? The most challenging part? TYLER: We trust each other. Also, we are best friends. KARI: We know each other so well. We can communicate without speaking and I know that he always has my back.

What is your favorite cocktail? TYLER: Hendricks gin and tonic. KARI: Bourbon, ginger, mint, and lemon.

Shabd

who	**Shabd Simon-Alexander**
location	**Williamsburg**
from	**Virginia and Maryland**
years in Brooklyn	**since 2001**

In 2000, Shabd Simon-Alexander moved to the city to study photography at New York University. For several years, she exhibited her work and collaborated with other artists before turning to fashion design. Today, Shabd is best known for her namesake clothing line, featuring beautiful color combinations and modern reinventions of tie-dye in classic designs. All of her pieces are dyed in her Williamsburg studio, which is just across the hall from her apartment. This is an ideal location for her extremely time-sensitive process (Shabd has been known to wake up in the middle of the night to take garments out of a dyebath). Working around the clock, Shabd draws much of her inspiration from her travels and the colors and textures of Japanese hand dyeing, Mayan brocade, American quilting, Afghan rug making, African weavings, Uzbek embroidery, and much more. Employing natural fibers and simple shapes that highlight her unique fabric, she aims to create timeless, seasonless pieces that can be worn for years and that are ecologically and culturally sustainable.

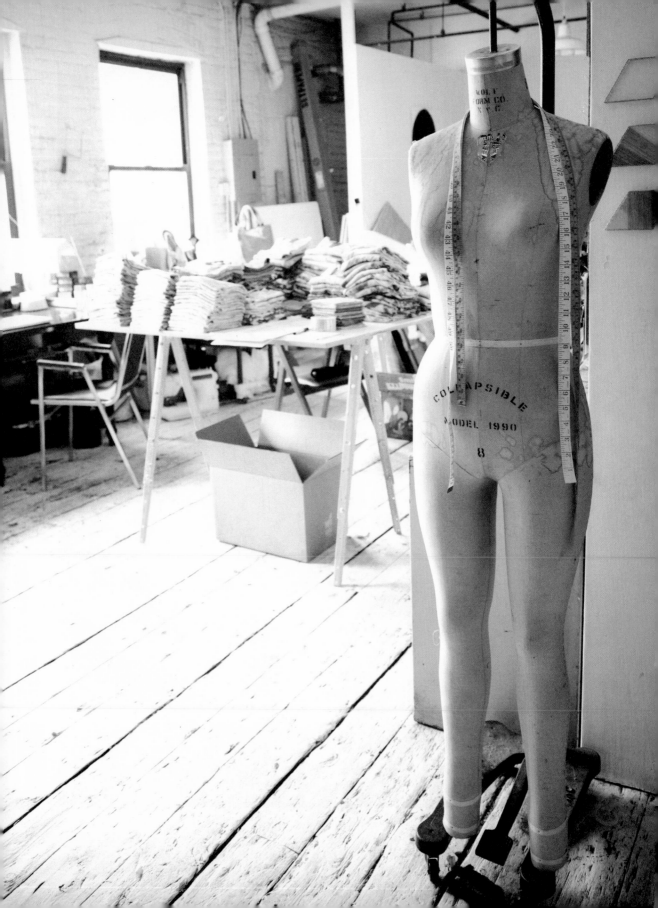

I love the reveal—all of the juxtapositions in dyeing, the planning and projecting, then letting go and being surprised by the results.

What brought you to New York? New York brought me to New York, and I suppose I found something of old New York in Brooklyn, a cross between dynamic and homey.

How has Brooklyn influenced your work? A feeling of entrepreneurship, curiosity, playfulness, intellect, and endless possibility.

Describe your toolkit. Excel. Buckets. Measuring cups and spoons. Whisks, funnels, spice jars, bottles, it looks like a kitchen with no food.

What is the most satisfying part of your making process? I love the reveal—all of the juxtapositions in dyeing, the planning and projecting, then letting go and being surprised by the results. I also love finding all of the little details that make each piece special. You can do the same thing ten times and have ten totally unique pieces.

Where do you find inspiration for your color palette? Texture everywhere: dirty sand with jellyfish bits in it, grass, moss, mold, rust, lichen, marble, fog, glaciers. Shibori dyeing techniques. Aurora borealis. Oil spills. 1960s skyscrapers in downtown Manhattan. Traditional American quilts. Modernist landscape paintings. The *Pagliacci* opera. Buckminster Fuller. Woolly vests from the Czech Republic. Tasseled tunics from Nigeria. Abstract expressionism. Contemporary wax prints from Africa. Ocean cliff sides in Sydney. Hand-woven textiles from Mexico and China. The floating hay islands of Peru. Afghan war rugs, Hubble photographs of Jupiter and the Orion Nebula. Drawings by one very talented four-year-old niece.

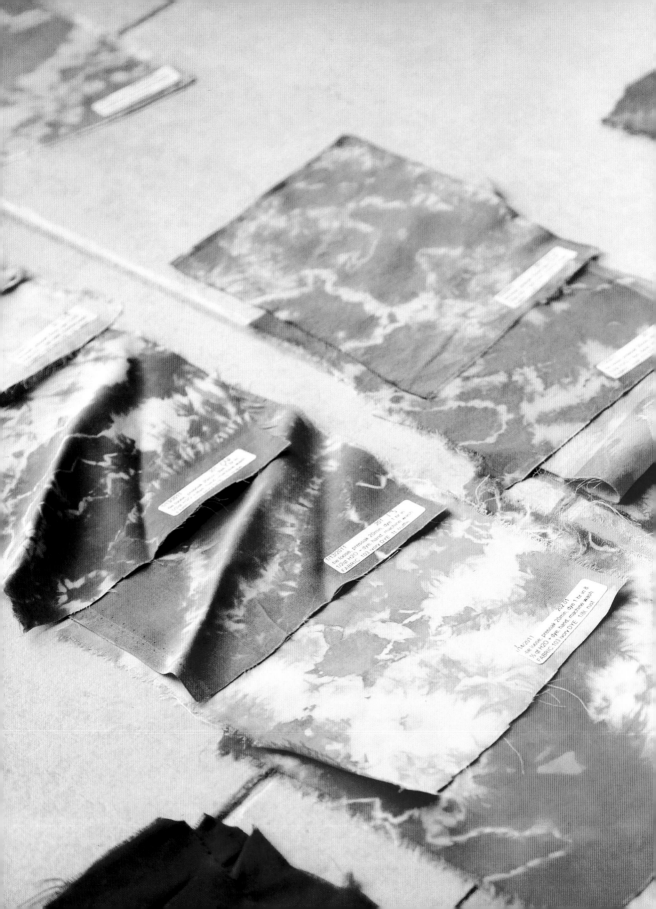

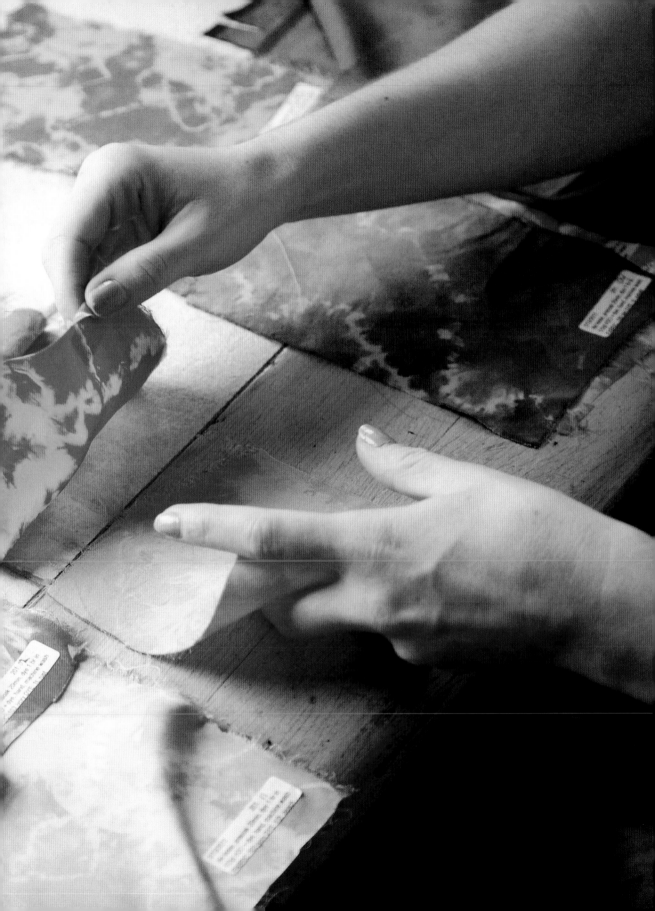

Blue Bottle Coffee

who	James Freeman
location	Williamsburg
from	California
years in Brooklyn	since 2010

Blue Bottle Coffee was founded by James Freeman in 2002 in Oakland, California. Only a few years after setting up his first coffee cart at a farmers' market, James expanded Blue Bottle to several San Francisco locations—and to Brooklyn. James decided to open his first roastery/coffee bar outside of California following a trip to New York with his wife (and Blue Bottle's pastry chef) in 2007. During the visit, James connected with many of Brooklyn's best, including Marlow and Sons and Mast Brothers Chocolate (he has collaborated with both: Bootleg S'mores made with moonshine from Kings County Distillery and the Brothers' chocolate, and biscuit sandwiches with ham from Marlow and Daughters). He opened up shop on Williamsburg's Berry Street in 2010.

Prior to James's success as a coffee connoisseur, he played the clarinet professionally. When his passion faded, he looked to coffee. A believer in "making things up as you go along," James taught himself how to roast coffee beans at home on a perforated baking sheet. Striving for only the highest-quality coffee, Blue Bottle still roasts all their own beans in-house, on vintage equipment, with a tight forty-eight-hour turnaround from roasting to customer. This allows for total control of the freshness and flavor profiles of the beans. The process remains hands-on, with a roaster carefully monitoring the temperature and listening for the first "crack" to ensure a proper degree of roast. James also prides himself on using only the finest organic and pesticide-free, shade-grown, single-origin beans.

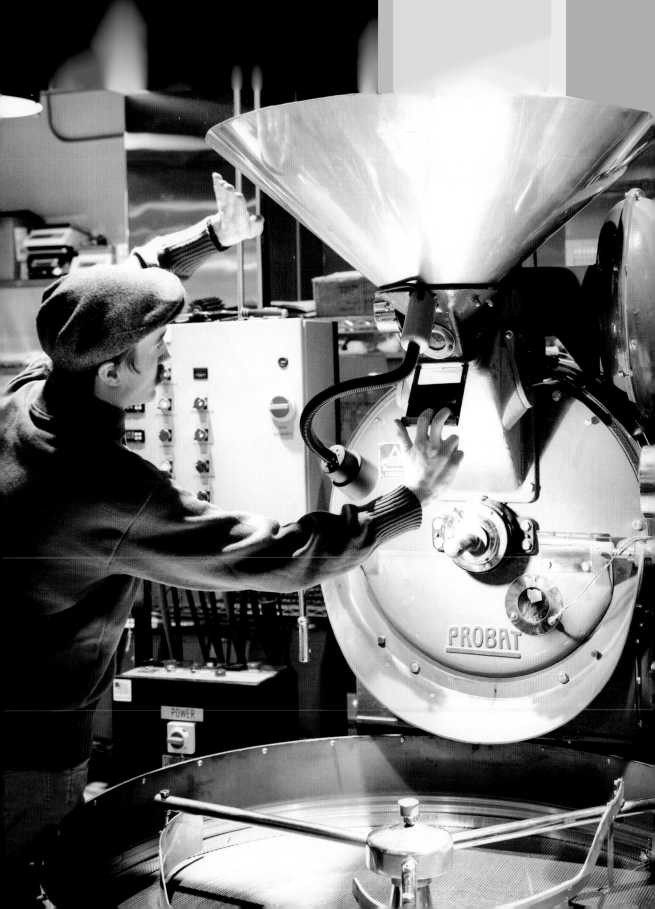

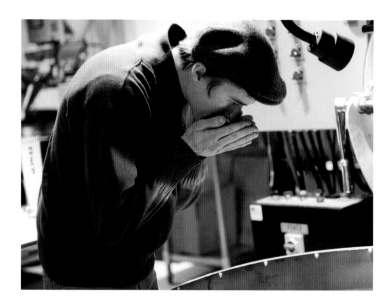

How do you get to work? In Brooklyn—jet plane, subway, walk. Sometimes cabs.

How do you take your coffee? Frequently! First thing in the a.m., usually around 6, I make myself a cappuccino on my old La San Marco Leva espresso machine, then usually I'll have a macchiato in one of the shops, then I'll cup some coffee, then have some pourover coffees (black, thank you), then an espresso in the late afternoon. I don't have an espresso machine in our Brooklyn apartment, so I'll make a pourover first thing before I head into the roastery.

What is the most satisfying part of your making process? The direct, short connection between roasting, bagging, and preparing coffee is so satisfying. Making a drink is a ninety-second performance. If it's an espresso, it takes another ninety seconds to consume. That's it.

What is the best part of working with your hands? Having a tangible product is just the best. I love that coffee smells so good, tastes even better, is fun to make, is delicious, and makes us smarter, funnier, happier, and more charming.

Do you remember your first cup of coffee? What impression did it make on you? I remember begging to open my parents' can of MJB coffee when I was four or five. I loved using a grown-up tool (the can opener) and I loved the spray of coffee smell that escaped just after puncturing the can. After a years-long campaign of pleading to taste the coffee, I remember being shocked at how horrible it was. That the taste could betray the smell so completely was shocking to me, and that tension compelled me to think more about coffee than I ordinarily would have.

I love that coffee
smells so good, tastes even
better, is fun to make,
is delicious, and makes
us smarter, happier,
and more charming.

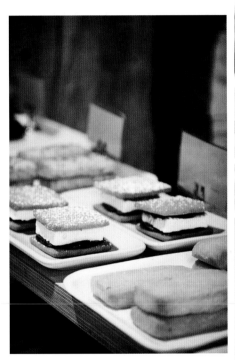

A roaster carefully watches
over the entire coffee-making
process, adjusting the equipment,
taking in the aroma of the beans,
and ensuring a top-quality,
perfectly crafted cup every time
(accompanied with mouthwatering
treats, like the Bootleg S'mores).

Lady Grey Jewelry

who	Jill Martinelli and Sabine Le Guyader
location	Bushwick
from	Jill: Massachusetts and Florida
	Sabine: Massachusetts
years in Brooklyn	since 2006

Jill Martinelli and Sabine Le Guyader met at Massachusetts College of Art and Design. Both studied metalsmithing and sculpture and found they shared a similar aesthetic and had similar backgrounds. While growing up, Sabine spent many afternoon hours at her father's dental office experimenting with various lab-related materials. One of her prized possessions (which she keeps in a drawer in her studio) is a steel rose that she sculpted from dental wax and that her father cast. Likewise, Jill's first after-school job was as an orthodontist's assistant, where she was fascinated by metal parts and medical oddities. While still in college, Jill and Sabine began selling some of their pieces in downtown Boston and soon after finishing school, they decided to move to Brooklyn to start their own metals and jewelry line, Lady Grey. These photographs were taken in Sabine's basement, where they previously worked, making each item by hand. Through close collaboration, Jill and Sabine create dark, conceptual, striking jewelry. They go back and forth with each other about ideas, materials, colors, and construction, working together toward the final piece.

Jill and Sabine (and their cat, Sayid) occupy a curiosity-filled studio in Bushwick, where they draw on their peculiar fascinations to create distinctive pieces.

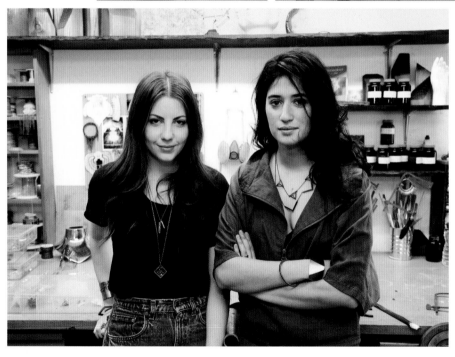

How do you get to work? JILL: With a lot of coffee and the G train. SABINE: Wake up and walk downstairs to the studio.

What is your favorite product that you make? JILL: I like to make anything that involves a lot of complicated soldering and construction. I would much rather spend a few hours on one piece than fifty pieces. I like the problem solving. SABINE: One of my favorite things that we make is chain fringe. It involves stringing chain link by link on a wire and then soldering. It's tedious but also relaxing because it's so mindless.

What is the best part of working with your hands? JILL: Making objects with your hands is one of the most primitive forms of human expression. You develop a very strong bond and addiction to the process of construction and making objects because it is so second nature. SABINE: Getting dirty!

How did you come up with the name of your business? The name of our line comes from sixteenth-century noblewoman Lady Jane Grey. At the age of sixteen, she was stripped of her throne and beheaded. She is remembered for approaching her execution with grace and poise. We have always been fascinated by her story and thought it fit the overall feel of our collection.

Do you sketch your designs before you construct them? JILL: I only sketch ideas with pen and paper about 15 percent of the time, the rest of the time I "sketch" in metal. For me, my ideas can get lost in translation from thought to paper to metal, which is why I typically go straight to making a rough three-dimensional model using the same materials that the final piece will be made of.

Who's the kitty? Sayid, the cat with a fetish for silver solder.

Kings County Distillery

who	**Colin Spoelman and David Haskell**
location	**Bushwick**
from	**Colin: Kentucky**
	David: Connecticut
years in Brooklyn	**Colin: since 2007**
	David: since 2004

Kings County Distillery was founded by Colin Spoelman and David Haskell in 2009. The distillery specializes in handcrafted bourbon and moonshine, using corn from farms in upstate New York. Colin grew up in Kentucky, where bourbon has a rich history, and met David in college. After testing some of their experimental, small-batch moonshine at a dinner party, Colin and David decided to go into business together. They began investigating what it would take to establish a legitimate distillery (making spirits at home, even for personal consumption, is a federal crime), and a year and a half later, they produced the first legally distilled whiskey in New York City since Prohibition.

For Colin, the wild character of parts of Brooklyn recalls his rural upbringing, and making moonshine provides a link to his Appalachian ancestry. The partners pride themselves on collaborating with other area makers. Blue Bottle Coffee uses their moonshine in Bootleg S'mores and they recently developed a chocolate-flavored moonshine with the discarded husks of cacao pods from Mast Brothers Chocolate. In addition, they barter with local businesses, like Morris Kitchen and hOmE, who built their tasting room for a barrel of bourbon and are now working on their expansion to a large space in the Brooklyn Navy Yard.

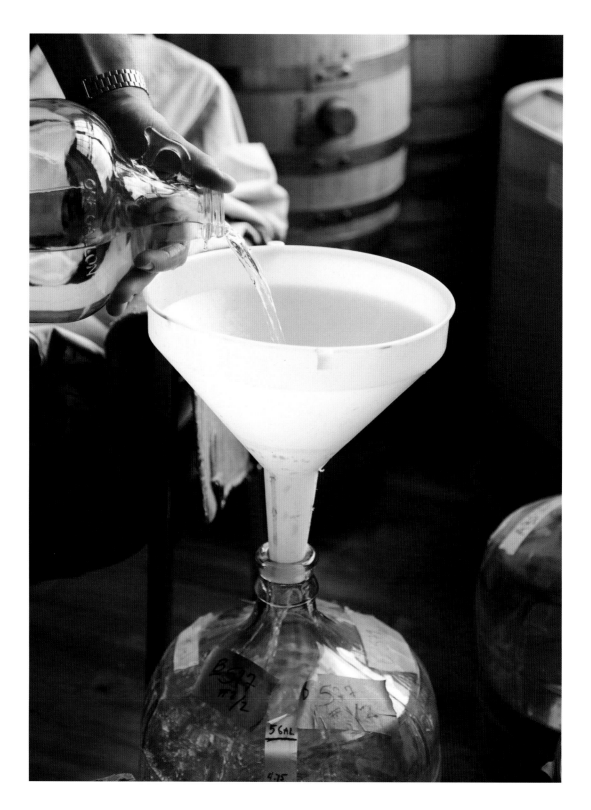

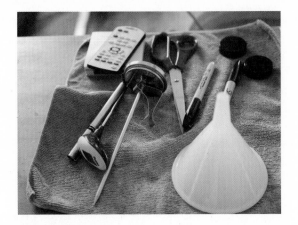

What hours do you keep? I just went part-time at my day job, so I'm more or less fifty hours a week at the distillery plus twenty-five at the architecture firm. David is full-time at *New York* magazine and will stay there. The distillery runs 10 a.m. to midnight, seven days a week, so I'm not always there, but the whiskey is always running.

Describe your toolkit in detail. The stills are the critical piece of equipment. They are comprised of a magnetic induction hotplate, a stainless-steel kettle, a column augmented with copper, and a cooling reservoir. They are highly unusual in a commercial distillery for their small size.

What is the most satisfying part of your making process? Opening barrels of whiskey after they've been aging is always the most rewarding part of the job. It's a delayed gratification that makes it sweeter, and there are slight differences in each of the barrels. But it's always nice to see that it's doing what it's supposed to do.

Where did you learn your craft? The real learning came from trial and error. There are very few hard rules in distilling; everything is subjective. So you have to try it all to have the feel for it. The innovations came from physical discoveries in process and ingredients, not anything I read about.

How did you come up with the name of your business? We conceived of an urban distillery, which at the time seemed very incongruous. We liked the name "Kings County" since it was evocative of Brooklyn and some place rural at the same time. It's also a bit sly; unless you pay taxes or have served on jury duty, most people don't know that Brooklyn is Kings County.

What does it mean to you to be New York City's first legal distillery since Prohibition? The history of distilling in the city is very rich, but has been mostly forgotten to time. Urban moonshining was a part of Brooklyn life for a lot of the nineteenth century. It's been an opportunity to discover that history and expand on it with our own shop.

*All questions answered by Colin Spoelman

Opening barrels of whiskey after they've been aging is always the most rewarding part of the job. It's a delayed gratification that makes it sweeter.

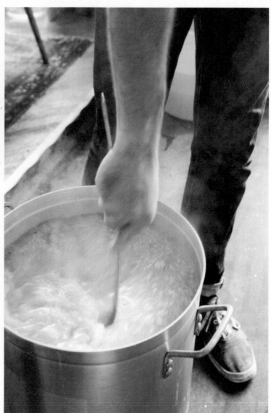

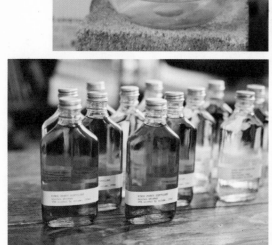

From a factory space in Bushwick, containing barrels, bottles, rudimentary tools, and bags of grain, Colin and David distill specialty moonshine and bourbon.

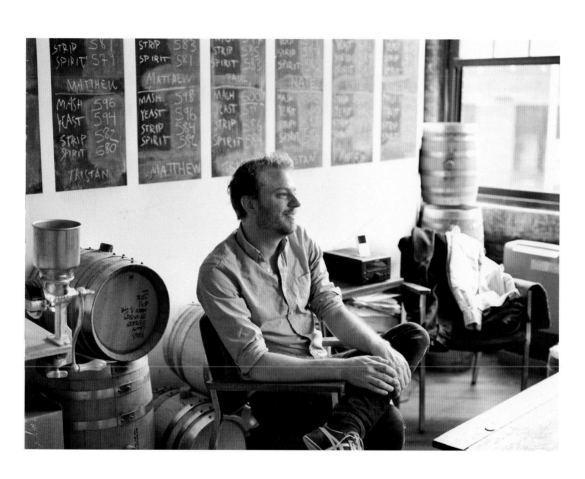

SOUTH

Traditionally, the cluster of neighborhoods south of Atlantic Avenue is considered South Brooklyn (with some liberties, the areas with makers included here are Clinton Hill, Fort Greene, Brooklyn Heights, Gowanus, Park Slope, Red Hook, and Sunset Park). Rich with history and impressive landmarks, such as the celebrated Brooklyn Bridge and Prospect Park (sister to Manhattan's Central Park), the area features brownstone- and tree-lined streets as well as revitalized industrial

BROOKLYN

communities (along the Gowanus Canal and the waterfront of Red Hook). Makers, ranging from ceramicists and florists to the many bakers and other food crafters, including Ovenly, Liddabit Sweets, and the borough's own Robicelli's, call South Brooklyn home. The exciting mix of classically preserved blocks adjacent to rugged, yet inspired spaces is quintessentially Brooklyn, and the perfect condition for creating the varied goods that follow.

Joya Studio

who	**Frederick Bouchardy**
location	**Clinton Hill**
from	**New York**
years in Brooklyn	**since 2004**

Founded by Frederick Bouchardy in 2004, Joya is a fragrance design studio that creates fine home and personal products, including candles, soaps, creams, and perfumes. *Joya* is Spanish for "jewel," which describes the crystalline finish of the first palm oil wax candles Frederick produced and is emblematic of the company's elegant goods. Joya crafts each piece using artisan techniques, from blending their unique scents to hand pouring their candles to slip-casting the ceramics that house their fragrances.

Collaboration is an important component of Joya's process. A lot of hands are involved in making each item and the pride of craftsmanship is apparent in the beautiful and high-quality results. Frederick seeks out the best sources from around the world, from glassblowers and injection molders in the south of France to metalsmiths and woodworkers in Brooklyn, and maintains a sampling and innovation area in the studio for experimentation with new scents and products. Additionally, Joya works with outside designers and artists to create specialized fragrances. They have collaborated with retailer Opening Ceremony on an exclusive candle set and ceramic artist Sarah Cihat on a limited-edition collection.

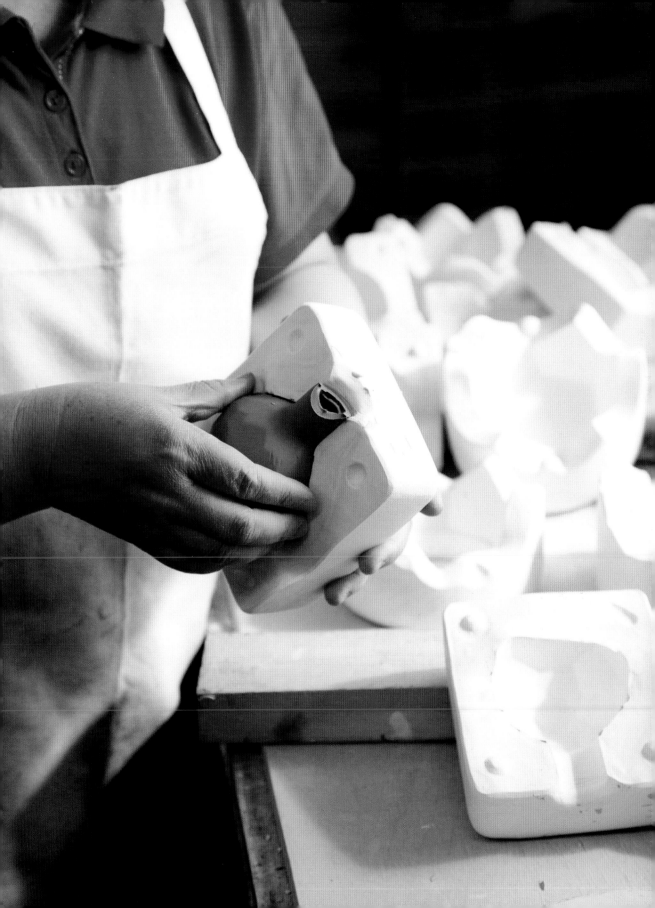

In the lofty Clinton Hill studio, Frederick and the Joya team (including cat Norman Bates) handcraft and test their unique fragrances and the ceramic containers that house them.

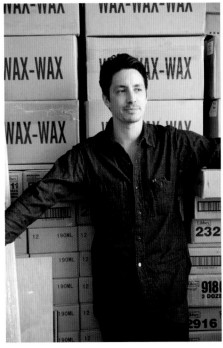

What do you see outside your studio window? The Brooklyn Navy Yard, the Brooklyn-Queens Expressway (BQE), and the occasional group of motorcyclists popping wheelies.

What does collaboration bring to your work? Have you been surprised by any of the results? Collaboration is a huge part of my business and brand. I enjoy working with designers and artists that specialize in other media. The results are usually unexpected and sometimes exceptionally cool. In essence, I can help others realize their visions through fragrance. Oftentimes, collaborative partners challenge us to innovate and to create scented items that don't even exist yet. I love a good challenge.

What does old-time New York smell like? Is there a modern interpretation? New York of the 1920s (*Mean Streets* or *Five Points*) smells like wet smoke, leather, wood, bourbon, and flowers struggling through cobblestones. I don't know of a modern interpretation. Maybe we should give it a go—maybe we already are.

Who's the kitty? That's Norman Bates. He was brought in as unofficial pest control, but we don't really have any pests. So, now he's mainly just a chubby mascot.

105

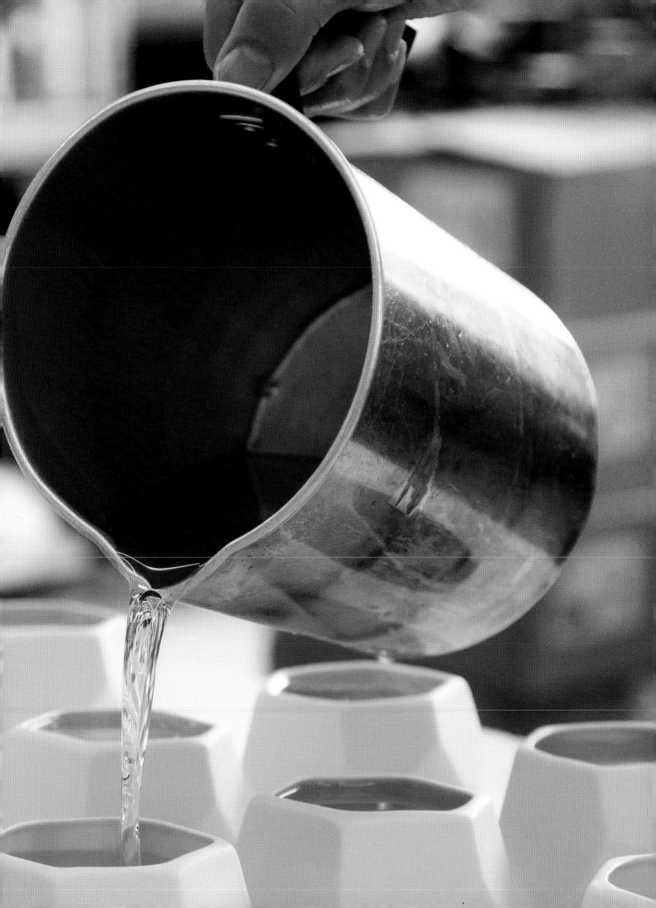

Lena Corwin

who	**Lena Corwin**
location	**Fort Greene**
from	**California**
years in Brooklyn	**since 2005**

Lena Corwin is a multidisciplinary artist— a printmaker, textile designer, illustrator, teacher, bookmaker, and prolific and respected blogger. In addition to her book *Printing by Hand*, which documents her printing techniques, Lena curates and produces publications as part of Lines and Shapes, an independent art and design collective she started with fellow artist Maria Vettese.

Primarily a self-taught artist, she is strongly influenced by her Northern California upbringing, often incorporating nature, flora, and fauna in her work. Lena moved to Brooklyn in 2005, following seven years in Manhattan. Her studio is located above her home on a tree-lined street in a 160-year-old classic brownstone in Fort Greene (an area known for its historic homes and park of the same name). Her space embraces many of the original features of the brownstone and reflects her clean, fresh aesthetic—white walls, wooden table, and a few carefully selected pieces of brightly colored artwork.

Lena often collaborates with other artists, both near and far, including several projects with Brooklyn fashion designer Caitlin Mociun. With her dog, Gustav, at her feet, she creates playful patterns that bring a sense of calm to urban life. Her new challenge is trying to balance work with motherhood. Lately, she is enjoying spending much of her days with her son, Eli, with whom she was pregnant during this photo shoot.

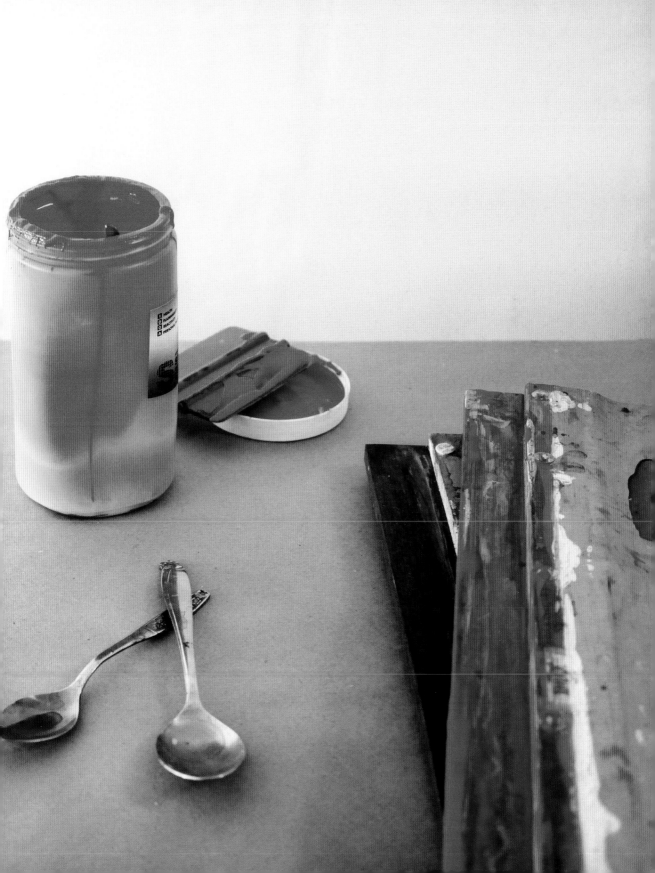

Working with vibrant colors, Lena prints her whimsical designs— mixing and spreading the ink, then with the even pressure of the squeegee, transferring the pattern to fabric.

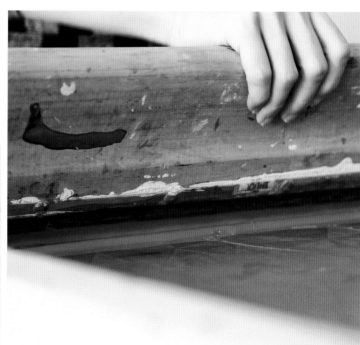

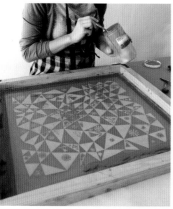

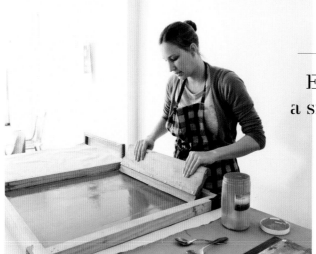

Each print is still
a small thrill for me.

Describe your toolkit in detail. Water-based screen printing ink, silkscreen frames, squeegees, spoons, cups for mixing ink, old towels, linen and cotton fabric, tape, and scissors. I try to reuse as much as I can (buying old flatware from Salvation Army for mixing ink, for example, instead of using plastic).

What is the most satisfying part of your making process? Screen printing is instantly satisfying. Each print is still a small thrill for me, and then standing back and seeing a finished batch of printed fabric is very gratifying.

What is the best part of working with your hands? Imperfections and inconsistencies.

How has becoming a mother changed your making process? I am much more conscious of toxins in the materials I use, and because of this I'm increasingly interested in natural sources like vegetable dyes.

How would you characterize the difference between collaborating with someone in Brooklyn and collaborating with someone you've never met? I love that it's so easy to collaborate with someone far away now, thanks to the Internet. But working in person is always better. When I collaborate with Caitlin Mociun, for example, she cooks me the most amazing lunches.

LENA CORWIN

The Jewels of New York

who — **Diana Yen and Lisel Arroyo**
location — **Brooklyn Heights**
from — **Diana: California**
Lisel: Puerto Rico
years in Brooklyn — **since 2007**

Long before styling and planning events, Diana Yen and Lisel Arroyo both learned to cook from their mothers, who instilled the importance of gathering around the table for a meal. The duo met while working together for event planner Colin Cowie, helping to design his first home collection. Realizing they shared a vision that combines a love of cooking and entertaining with the beauty of everyday things, they formed the Jewels of New York with the mission of bringing a sense of warmth and home cooking to clients through catering and food styling.

They started their business out of Diana's apartment in Brooklyn Heights, a historic neighborhood filled with architectural details and cobblestone streets, and conveniently located within walking distance of the Borough Hall farmers' market. With Diana's background in product design and Lisel's in graphic design, they were able to quickly develop their brand and streamline their creative process. Whether food or design, they apply the same logic and sensibility to all of their projects, creating special details for their one-of-a-kind vision. When working as food stylists for magazines, each job is unique. Some days they conceptualize story ideas, develop menus, and test recipes, while other days they shop for props or work on set: directing, cooking, or styling a photo shoot. Diana and Lisel have recently moved into a new studio in Soho and are writing their first cookbook.

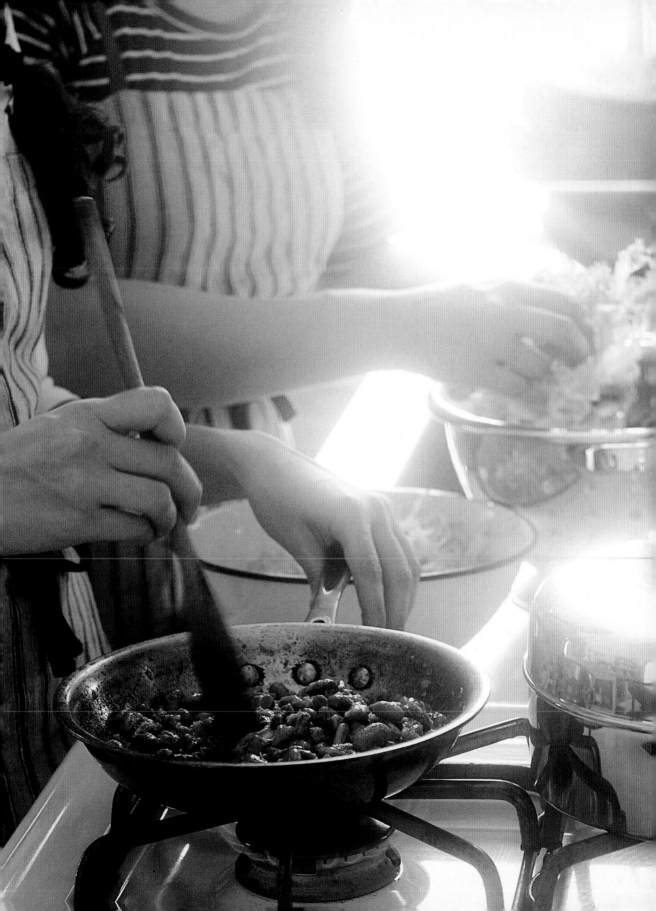

Most of our inspiration
comes from discovering
New York and all the beautiful
things that grow here.

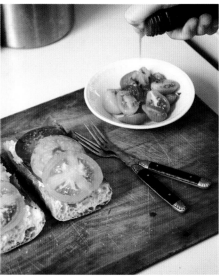

Diana and Lisel shop the
farmers' market, review a
favorite recipe, and prepare
and enjoy a simple, well-
styled meal in their cozy
Brooklyn Heights kitchen.

114

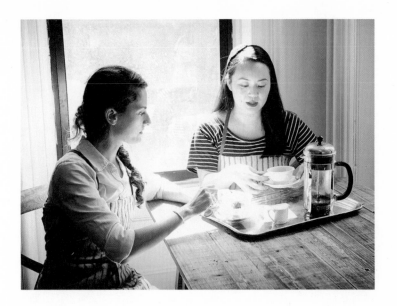

What do you see outside your studio window? Historical brownstones and hundred-year-old trees line the street.

Describe your toolkit in detail. In our styling kit, we always carry: long tweezers, cut-up paper towels, Q-tips, Windex, styling wax, chef's knives, scissors, and tape. Sometimes fake ice cubes when we are styling drinks.

What is the most satisfying part of your making process? The most satisfying part of our work is tasting the food and seeing the photographs after a shoot. And we always invite our friends over to eat the leftovers afterward.

What is the best part of working with your hands? The best part of cooking is being able to use all of your senses and enjoy the results quickly. Food gives us an immediate pleasure and can be shared with others—it's one of the most intimate and nurturing acts a person can offer to another.

What is the most significant investment you've made in your business? Sleep. Sometimes we have to wake up at 5 a.m. for the markets or to prep for a shoot. Days can be long and physically exhausting, but the results are worth it. You fall asleep feeling like you're living the life you've always wanted.

How did you come up with the name of your business? Most of our inspiration comes from discovering New York and all the beautiful things that grow here. The Jewels of New York is about uncovering treasures and sharing them with people.

Four & Twenty Blackbirds

who	**Emily and Melissa Elsen**
location	**Gowanus**
from	**South Dakota**
years in Brooklyn	**Emily: since 1999**
	Melissa: since 2009

Emily and Melissa Elsen learned to bake from their mother, grandmothers, and aunts. Growing up, they frequently talked about starting a business together. When the sisters, originally from South Dakota, found themselves once again living in the same area, they knew the time was right to open Four & Twenty Blackbirds, a pie shop.

Finding a warm and welcoming space for their new endeavor was of utmost importance. Emily also wanted to work in close proximity to the Gowanus Studio Space, a nonprofit workshop for designers, artists, and entrepreneurs that she founded. They decided on a light-filled corner storefront located on Third Avenue and Eighth Street. They restored the original tin walls and wood floor, and had the kitchen area and countertops constructed with reclaimed wood beams.

At Four & Twenty, the pie flavors—salted caramel apple, bourbon pear crumble, grapefruit custard, black bottom lemon, and many more—change with the seasons, and Emily and Melissa try to add a new fruit to their repertoire each summer. Recent favorites include figs, apricots, and rhubarb, as well as uncultivated edibles such as wild ginger. They source the majority of their fruit and dairy locally, and use coffee from Irving Farm Coffee Company, roasted in the Hudson Valley. Despite the plethora of appetizing fillings, they consider the crust to be the most important part of the pie. "It's the beginning," they note, "without a well-made crust, none of it works."

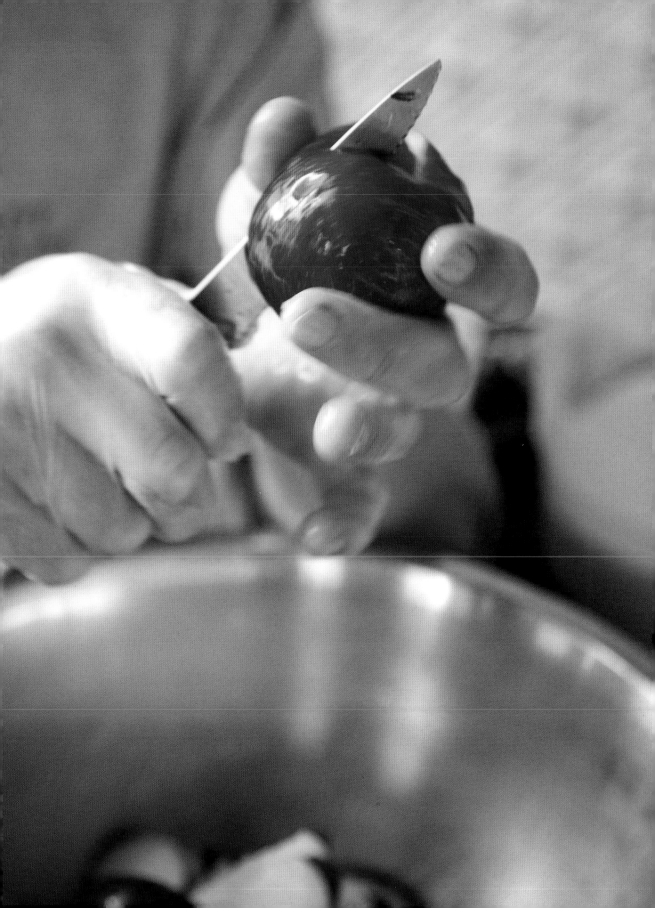

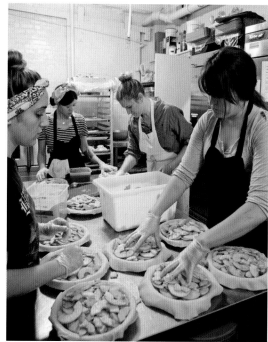

From the kitchen of their sunny storefront in Gowanus, Emily and Melissa and the Four & Twenty crew create their signature pies around the clock, from crust to fresh fillings to baked perfection.

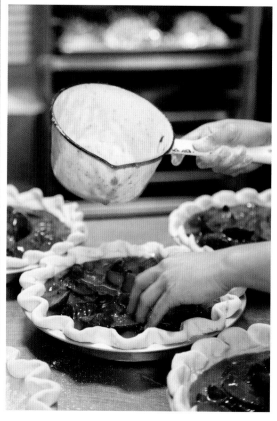

EAT MORE PIE!

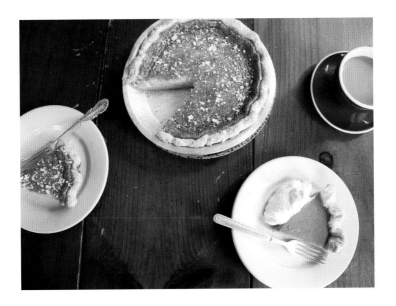

What do you see outside your shop window? EMILY: Our window boxes filled with herbs; Eighth Street, which is a quiet, tree-lined side street; and Third Avenue, which is a busy, postindustrial strip (but changing). MELISSA: Our neighbors: tradespeople, artists, professionals, scrap metal collectors, and fellow small business owners.

What is your favorite product that you make? MELISSA: I love making piecrust. Like most doughs, it's a hands-on process but doesn't require a lot of thought, just feel and intuition. To me, an hour of making piecrust is a quick one.

How did you come up with the name of your business? EMILY: A family friend suggested we look to nursery rhymes for inspiration. We wanted something dark and light but not sweet or cutesy and it fit the bill perfectly.

What is the best part about working with your sister? The most challenging part? EMILY: I trust her deeply, she is smarter than me, and we argue productively. We're so close, sometimes it can be challenging to be objective. MELISSA: We can be blunt and honest. Sometimes too blunt and honest.

Do you barter with or purchase from other Brooklyn makers? EMILY: To name a few close by: Brooklyn Homebrew are our neighbors and they bring us delicious home-brewed beer, and we talk spices and recipes with them; we sell Salty Road saltwater taffy at the shop and we collaborated with Marisa Wu on a salted caramel apple pie taffy flavor; Cut Brooklyn is down the street from us and Joel Bukiewicz generously keeps our knives in great shape; our neighbor Frieda Lim has an amazing rooftop garden called Slippery Slope Farm and she provides us with herbs and veggies throughout the summer; Steve Hindy, the founder of Brooklyn Brewery, is our neighbor as well, and they've participated in events at the pie shop; the Gowanus Studio Space members are our customers and we offer them a coffee discount—and if we ever need special projects, we'd call on any of the talented folks there.

What's your strategy for creative block? MELISSA: With all of New York City at your disposal, inspiration is everywhere.

Lotta Jansdotter

who	**Lotta Anderson**
location	**Gowanus**
from	**Scandinavia**
years in Brooklyn	**since 2006**

Scandinavian-born Lotta Anderson moved to Brooklyn from San Francisco in 2006. She is a creative maker extraordinaire; she designs products, patterns, and textiles and illustrates and writes lifestyle books, among many other things. For over twenty years, since arriving in the United States, Lotta has built her company, Lotta Jansdotter. Jansdotter is a combination of her father's name, Jan, and *dotter*, Swedish for daughter.

Lotta makes all her designs by hand, adding her distinct style to the basic craft skills she learned as a child—drawing, printing, and sewing. Regarding her hands-on process, she states, "I love touching and feeling the paper, cutting and playing around with the shapes, getting

sticky glue on my fingers. The tactile experience is very important to me when I create." She also credits travel as an inspirational and productive part of her business—introducing details, colors, textures, and patterns, and opening up partnerships internationally. Through her whimsical and worldly approach, Lotta develops projects and products that are simple and sophisticated, fun and functional.

Lotta recently moved to a studio in Gowanus, an industrial neighborhood located between the residential areas of Park Slope and Carroll Gardens along the Gowanus Canal. The new space acts as a creative workshop, where Lotta also teaches classes, and a storefront for her varied goods.

How has Brooklyn influenced your work?
Brooklyn has influenced my work in more ways than
I probably know. I use stronger and more vibrant
colors now. The work is bolder and brighter—
just like New York!

Describe a typical day at work. Some
days are photo shoots, some days are sitting in
front of the computer trying to catch up on email.
Sometimes I cut and paste paper or sit and eat
pie, and sometimes I scurry around and get nothing
done. Some days I sort and organize my artwork,
plan new books, cut fabric, or talk to customers.

**What is the most significant investment you've
made in your business?** My first airplane ticket
to Tokyo, Japan, in 1998. That visit led to so many
wonderful opportunities, connections, and work.

Describe your toolkit in detail. The whole
workshop is my toolkit: the inspiring books and
scrapbooks with clippings that I have saved.
All my scissors, my pens and paper, all the different
teas in my cupboards, the brushes, the new iPad,
the mint plant, the hand lotion, my copy machine
(super important), rubber cement, the music in
the speakers, the industrial felt, the inks, the port,
and yes, the laptop…and so on and so on.

What's the first item that you ever made?
I did a lot of drawing as a kid. When I was nine,
I made a white cotton drawstring bag on the
sewing machine, with a red cord and strawberry
appliqué. I still have it.

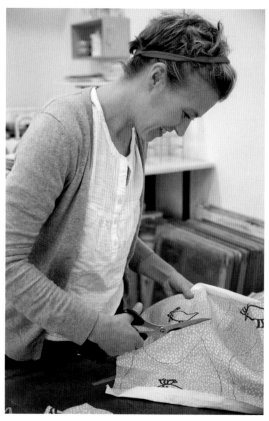

Lotta's new Gowanus
workspace and storefront
is inspiration central.
She sketches, prints, and
sews in-process works
and showcases (and sells)
completed creations—
batches of fabric, mugs,
bags, and much more.

Brooklyn has influenced my work in
more ways than I probably know. I use stronger
and more vibrant colors now. The work
is bolder and brighter—just like New York!

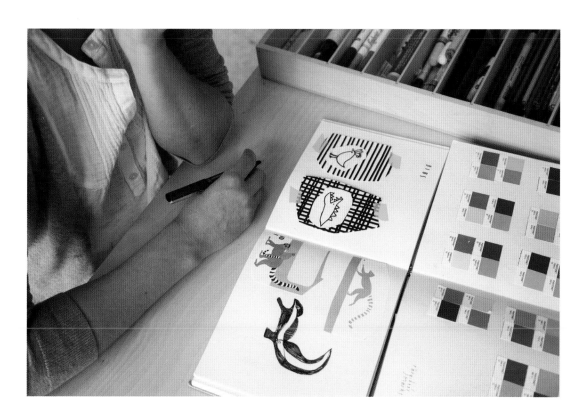

LOTTA JANSDOTTER

Reverie

who	**Alison Woodward**
location	**Park Slope**
from	**Louisiana**
years in Brooklyn	**since 2004, off and on**

Alison Woodward creates exquisitely detailed necklaces, bracelets, earrings, rings, and more for Reverie, her jewelry design studio. All of her pieces are made from vintage and antique parts (flea market finds), redesigned with a modern take. Alison is a self-taught designer, although she credits her studies in architectural preservation and interior design with helping to develop her sense of proportion, balance, and detail—all evident in her ambitious jewelry. Rather than sketch her ideas, she designs each piece by working with a handful of varied materials (beads, wire, vintage metal stock) and arranging compositions until the elements come together in just the right way. One of her favorite activities, which fuels her creativity and her business, is visiting flea markets. Her sister, who lives in the building next door to Alison, often accompanies her to the markets and provides important feedback on new designs. Alison's studio is located in a small room in her ground-floor Park Slope apartment, facing the backyard. It is light filled (and jewel packed) and perfect for working mornings, which are her most productive time. The quiet space is the ideal foil to the bustling Fourth Avenue right outside her front door.

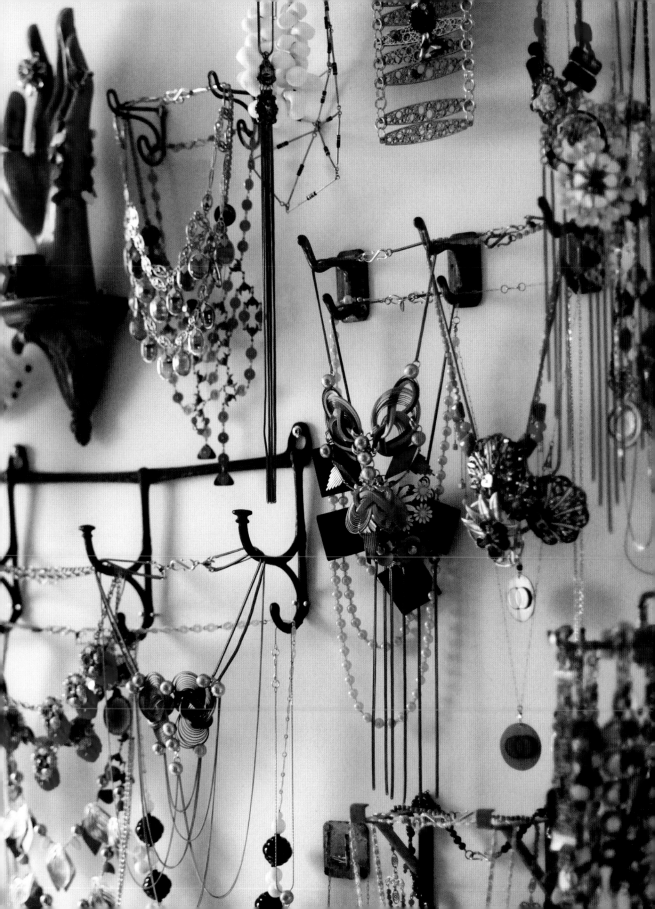

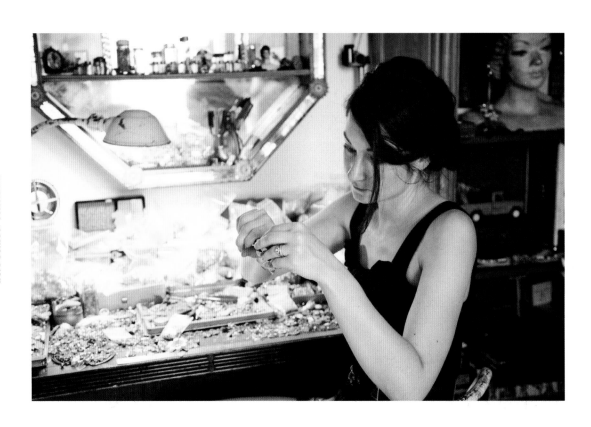

What did you look for in a studio space?
A door and a window! In my previous apartment in Manhattan, I was working out of my living room. It was charming but not ideal. The apartment I'm in now has a little spare room—with a door and a window. It's perfect!

What do you see outside your studio window? My studio is in the back on the ground floor, which is just above the neighbor's yard. It has a beautiful tree that grows pink flowers in the spring. There are birds that sing, squirrels that run around, and a couple of cats that sunbathe regularly. Also, there is a grapevine growing on the building, so in the fall I can see gorgeous purple grapes hanging in front of the window.

What is the most satisfying part of your making process? When the elements of a piece come together, I get this surge of excitement. My heart beats faster and I can't finish it fast enough. That feeling of satisfaction in one design will propel me right into the next one. It's what I hope for every time I sit down to work.

The small, garden-facing studio of Reverie is filled with treasures—vintage finds, from intricate jewelry pieces to framed inspiration, and her kitty, Eliza.

Ovenly

who	**Agatha Kulaga and Erin Patinkin**
location	**Red Hook**
from	**Agatha: Connecticut**
	Erin: Illinois
years in Brooklyn	**Agatha: since 2001**
	Erin: since 2007

Agatha Kulaga and Erin Patinkin first met in a food-focused book club. Even before they formed their friendship, they started talking about going into business together. After a year of planning, they launched Ovenly, baking snacks and desserts that deliciously combine salty, sweet, and spicy.

Being a part of the thriving Brooklyn food community has both inspired and challenged the partners. They credit the pervasive entrepreneurial spirit of the borough and the network of generous people for much of their success. As Agatha states, "I don't think there is another spot in the country that would have provided Ovenly with the opportunities that have come our way." The challenging part, however, was creating a niche for themselves. They have achieved this with their unique flavor combinations like cheddar cherry basil scones and spicy bacon caramel corn. Collaborating with like-minded companies has also resulted in some noteworthy pairings: bourbon chocolate tarragon cookies for Coolhaus (an ice cream sandwich food truck) and espresso burnt sugar shortbread for Stumptown Coffee (dubbed the "Stumptown Shorty"). They pride themselves on using ingredients from other local makers, for instance Brooklyn-based Tin Mustard provides the key ingredient for their mustard spice cookies and Brooklyn Brewery beer is used in their chocolate stout cake with salted caramel frosting. Ovenly recently moved their headquarters to a large space in Greenpoint, where they have a kitchen and cafe.

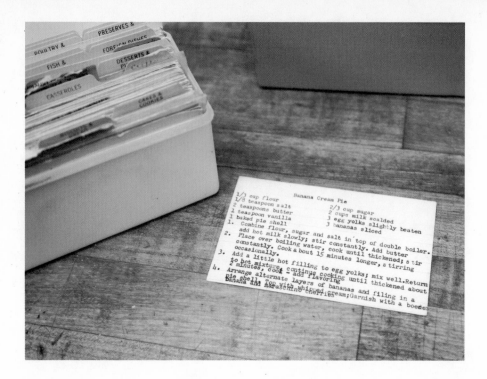

How has Brooklyn influenced your work?
Brooklyn is home to a large group of young people who are trying to "make it"—artists, musicians, chefs, techies, distillers, fashion designers, filmmakers, what have you. Everywhere you look, someone is working on an interesting project. It's inspiring.

Plus, Brooklynites (and New Yorkers in general) are obsessed with food. That simple fact has been quite helpful to our success.

What is the most satisfying part of your making process? ERIN: For me, experimentation is the most satisfying. It's just plain fun to combine ingredients to make interesting baked goods and bar snacks. Coming up with a winning recipe is like my own personal trophy because that success means I've also gone through a lot of failure. AGATHA: For me, it's figuring out the science behind each step and how it impacts the final product. Sometimes this means working backward to figure out the puzzle, which I love. Our kitchen always feels like a big science project.

What is the best part of working with your hands? ERIN: It's a Zen experience. There's never been a day that has seemed long, boring, or drawn out since we started Ovenly. AGATHA: Working with my hands has always been my own form of meditation and relaxation. I played the piano for about nine years and when I stopped, the energy in my hands was channeled into baking.

What is the best part of collaboration?
Our mutual drive and complementary strengths. We can work throughout an entire day knowing exactly what we need to do, without speaking— maybe with an occasional grunt here and there— we've developed a real rhythm and private little language. Our strong partnership has been our success. Also, having someone else to laugh and cry with during this start-up phase has probably kept us both sane.

Describe a flavor combination that didn't work. Beef jerky and chocolate (do not try this at home).

Agatha and Erin experiment with unexpected ingredients to concoct their unique, and supremely tasty, treats, such as the Stumptown Shorty, an espresso burnt sugar shortbread.

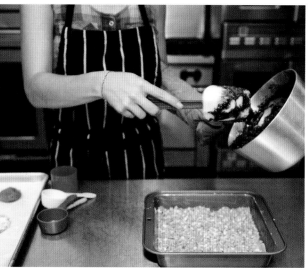

135

PELLE

who	Jean and Oliver Pelle
location	Red Hook
from	Jean: South Korea and California
	Oliver: Germany
years in Brooklyn	Jean: since 2005
	Oliver: since 2000

Husband and wife Oliver and Jean Pelle met while studying architecture at Yale University. Years later, they reconnected in Brooklyn, where they now live and work. In 2008, following positions at several design firms, Jean opened her own studio, combining her penchants for objects, interiors, and making. She launched her business with her unique wooden candleholders, which were quickly picked up by boutiques across the country. She then expanded the work to include small furnishings and the celebrated bubble chandelier (pictured). In 2011, with the success and momentum of the studio, Oliver left his architecture job and joined Jean to form PELLE, where they practice in the fields of product, furniture, interior, and architectural design. The couple resides in Red Hook (an old industrial area located along the East River south of Manhattan), with their studio just a short walk from their home. They appreciate the quiet, more focused time away from the bustle of the city and take full advantage of their lack of commute, spending the extra hours with their young daughter, Lia. The Pelles recently debuted the Quadrat series of furniture (a strongly grid-based line undoubtedly inspired by their architectural backgrounds) and opened up a showroom near their studio.

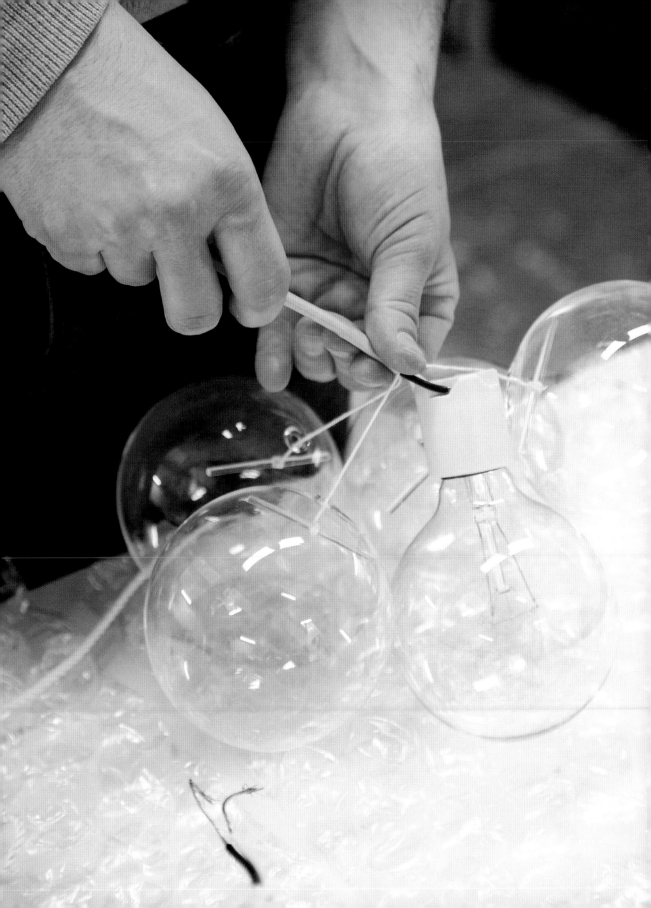

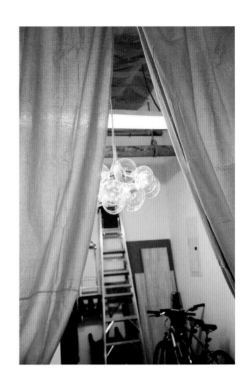

What brought you to Brooklyn?

OLIVER: I always wanted to live in a loft. When I came to New York, I looked for a place to live and found a bare loft space in South Park Slope that I eventually built out. I loved the heterogeneity of the neighborhood. Brooklyn also has this raw energy of incompleteness where it feels as if anything has potential.

How has Brooklyn influenced your work?

JEAN: Brooklyn is a place filled with entrepreneurial, creative types that are constantly stoking your own flames and ambitions. I think just the sheer energy is influential. It's also helpful to be based here because there are many local resources for designers such as studio space, wood and metal shops, and other fabricators.

Where did you learn your craft?

JEAN: For me, learning to make things began while I was growing up, when I would help my sculptor father in his studio. He worked a lot with plaster, foam, clay, and molds. When I made the wooden candleholders, I taught myself the lathe by watching an instructional DVD and reading a couple of books on the subject. Sometimes, that's all it takes to learn something new. OLIVER: I feel more like a designer than a craftsman. Our work is not specific to one type of craft. As an architect, you learn about the various aspects of building a project. On the one hand, you learn how to methodically work through a problem and plan for the best way to execute it. On the other hand, probably the more challenging one, you learn to be intuitive and express yourself through drawings and models. Actually making something is still how I find myself learning the most.

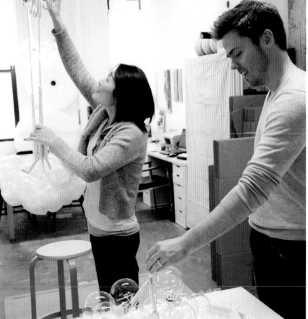

Jean and Oliver Pelle make (and package) the bubble chandelier in their bright, well-organized Red Hook studio, which also features wooden candleholders, color studies, and a bit of natural adornment.

Saipua

who	**Sarah Ryhanen**
location	**Red Hook**
from	**New York**
years in Brooklyn	**since 2004**

The tiny, weathered wood–clad shop of Saipua feels worlds away from its industrial Red Hook location. This is the world created by floral stylist and designer Sarah Ryhanen. The space is filled with unique, handpicked items, signature soaps, and lots of fresh flowers. Sarah owns the shop along with her partner, Eric Famison. Saipua, derived from the Finnish word for soap, began as a family endeavor—soapmaking with Sarah's mother. Although they still make and distribute soap all over the country, Sarah's focus has turned to her flower business.

With her beautiful arrangements (not to mention her sharp wit), she has established a loyal following. Her studio is located behind her shop, where she also hosts classes with fellow Brooklyn designer Nicolette Camille, as part of their collaborative project the Little Flower School. Sarah and Nicolette travel nationally and internationally to gather inspiration (recent trips include Iceland and Paris). Closer to home, Sarah and Eric recently purchased a nearly two-hundred-year-old farmhouse in upstate New York. The farm, previously owned and meticulously maintained by arborists, sits on over one hundred acres, which they plan to use to grow their own flowers, including fritillaria, tulips, and irises, as well as hellebores, autumn anemones, ferns, wildflowers, and much more.

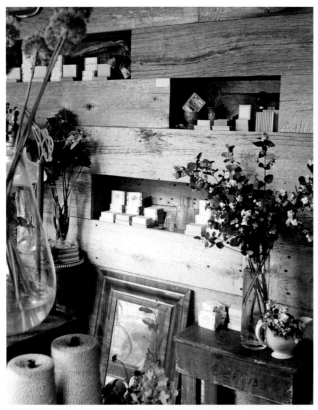

In the flower studio, filled with seasonal blooms and busy hands, Sarah creates one-of-a-kind arrangements. In the shop, handpicked items and signature soaps line the rustic walls and vintage tables.

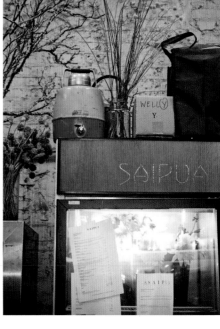

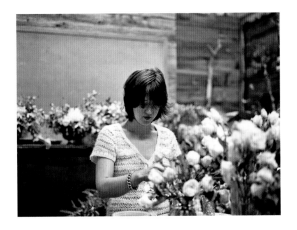

Describe a typical day at work. Every day is so dramatically different. That's one fantastic thing about being an event-driven studio; no day is like the last. But in general, I have four types of days: 1. 7 A.M. Wake up, coffee. Computer, email, breakfast. Studio by 10 a.m. Meeting with my girls about the week. Paperwork. Consultations. Maybe an arrangement or two is made, maybe I do some photo work. 2. 5:30 A.M. Wake up, shop flower market. Back to studio at 9 a.m. to prep and make on-site installations. These are the most fun but also the most draining. We do our own packing and hauling so by the end of the day I'm done for. A big martini and steak around 8 p.m. 3. CITY DAYS! I love these days—when I go to Manhattan in Manhattan-like clothes and have meetings and run errands. 4. FARM DAYS. We just started a flower farm upstate and these days are spent almost exclusively outside digging and planting. Composting. Walking, learning. So much learning happening there, it's exciting.

What's your strategy for creative block? Take a walk with my dog. I call them meditation walks, which is kind of a joke because I'm not meditating; rather quite the opposite, I'm brainstorming. They last hours. I get all my thinking done walking.

Describe your toolkit in detail. It's three kits in one. We keep it very organized now. The outer kit is a big bag that has a hammer, nails, trash bags, rags, spray bottles, duct tape, wrenches, and other stuff like that—a bag of mixed nuts sometimes. The next kit is inside and has the serious floral tools: the clippers (four or five pairs), a few holsters for the clippers, the tape (both soft and plastic tape), scissors, fishing wire, floral wire, rubber bands, and box cutters. The most interior kit is a small, soft bag for fancy ribbons and pins.

Can you talk a little about the farm you just purchased upstate? It's 110 acres about 150 miles north of the city. I can't tell you how lucky we were to find it and to be able to buy it. Dumb luck. The farm was built in 1820. The land is breathtaking. There is a 250-year-old maple tree. The previous owners were arborists and they preserved the land so beautifully. I feel honored to be the next to use and watch over it. I was there recently doing some work and I found myself feeling happier than I've felt in a long time. I'm not usually prone to happiness, but that place brings it out in me. We're also going to grow our own flowers—the list is endless. It is a lifelong project.

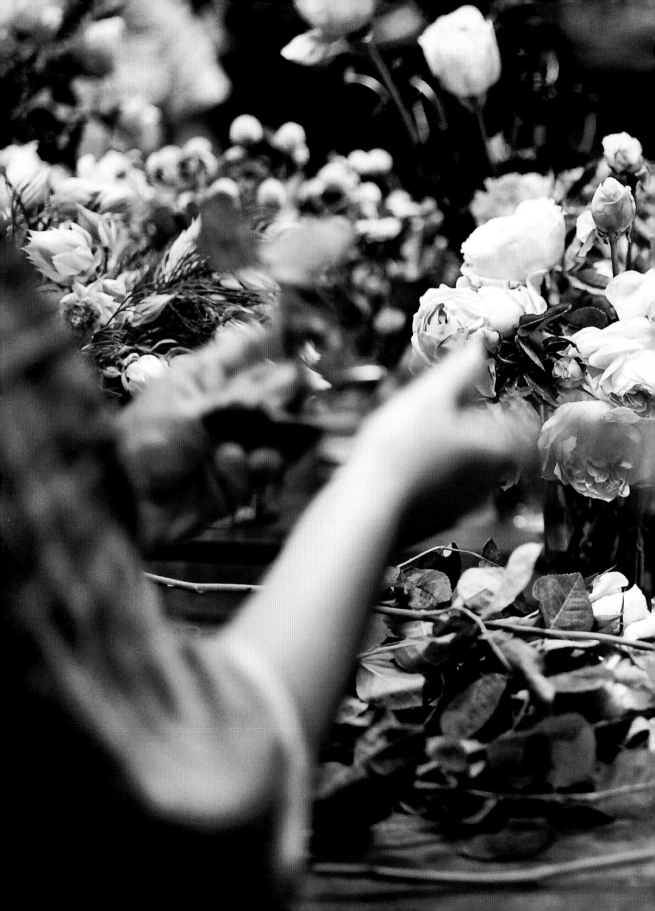

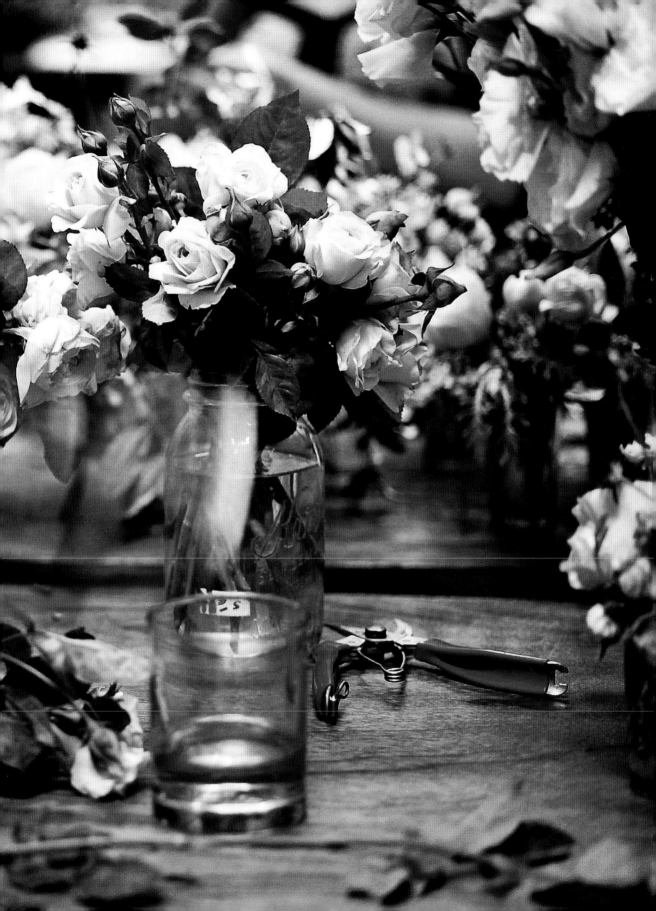

Elephant Ceramics

who	**Michele Michael**
location	**Red Hook**
from	**New York**
years in Brooklyn	**since 1996**

Michele Michael designs and creates tableware as Elephant Ceramics. Although she began working with clay only a few years ago, her line has quickly become sought after by those with an appreciation for quality handmade products. She started her career as a magazine editor, first as an assistant in the decorating department of *House & Garden,* then branched out to write *The New Apartment Book,* a how-to guide to decorating small spaces. Later, she began freelancing as a prop stylist for magazines and advertisements and eventually opened her own prop house in Manhattan called Elephant Props (named for her affinity for elephants).

When Michele enrolled in classes at a neighborhood ceramics studio, she began experimenting with various techniques. She found her niche in organic, hand-built pieces, making small plates and platters using a rolling pin, a Shimpo banding wheel, and numerous sculpting tools. She adds texture to the pieces by pressing homespun linen into the clay and marks each work with her signature elephant stamp. To finish, she glazes the pieces with artful drips and brushstrokes in beautiful, far-ranging shades of blue and green. When in Brooklyn, Michele works out of a communal space in Red Hook, sharing knowledge and experience with her studiomates. In the summer, she heads to Maine, where she has rented space at the Watershed Center for the Ceramic Arts. She is currently in the process of building a barn on her Maine property to house her own ceramics studio.

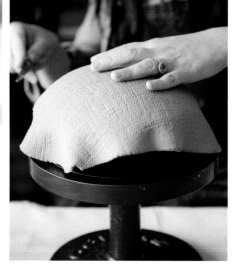

Michele, in her very blue studio, rolls clay on linen, shapes a dish, then stamps it. The crafted forms are hand glazed with a gradient of ocean-inspired colors.

What brought you to Brooklyn? Love!

What do you see outside your studio window? Industrial buildings, lots of trees and sky.

What is your favorite product that you make? My cheeseboards may be my favorite. They look like the easiest thing to make, but are actually the hardest in that their success rate is fairly low (many crack or break in the kiln). I love cutting out the shapes. They may be organic, midcentury inspired, or based on antique French wooden cutting boards.

How do the works you produce in Brooklyn differ from those you make in Maine? I tend to do larger pieces in Maine. I think it has to do with simply having more space.

What is the most significant investment you've made in your business? A barn— which is going to be my ceramics studio! We are currently building it on our property in Maine. It's a timber-frame barn. We used wood from our property to build it. All the timbers are hand hewn with a broadax. They are gorgeous. The walls are going up now. I am hoping to be able to use it as a working studio in the summer.

What do you most look forward to when returning to Brooklyn? Oh, the food! The greenmarket and all my favorite restaurants like Franny's, Marlow and Sons, and Fort Defiance.

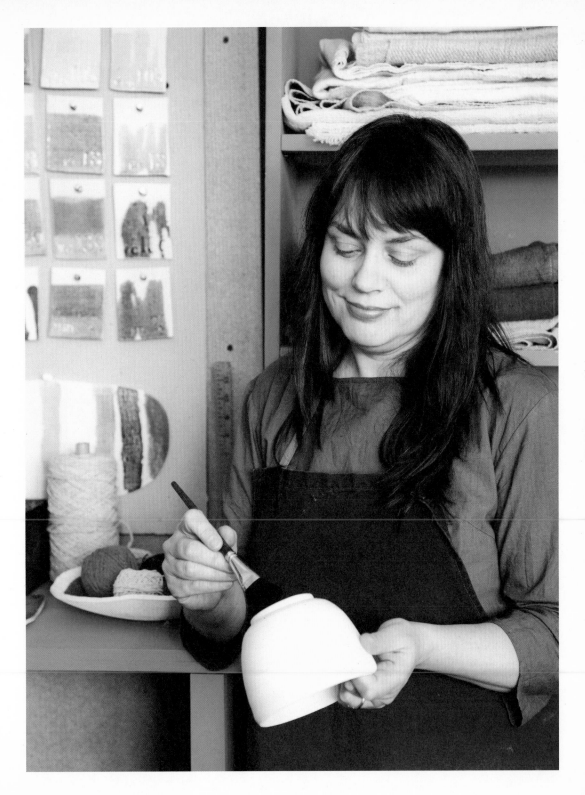

Liddabit Sweets

who	**Liz Gutman and Jen King**
location	**Sunset Park**
from	**Liz: California**
	Jen: Michigan
years in Brooklyn	**Liz: since 2009**
	Jen: since 2007

Liz Gutman and Jen King met while attending the French Culinary Institute's pastry program in New York City. Both passionate about making delicious sweets with high-quality ingredients, they began experimenting in the kitchen and selling a few treats at local markets. In 2009, they formed Liddabit Sweets (named after a childhood nickname of Liz's), a candy company. In May of that year, they landed a spot at the popular Brooklyn Flea, a weekly market in Fort Greene and Williamsburg that features local and regional vendors and has become known as an incubator for many Brooklyn food artisans.

One of their first products was a reverse-engineered Snickers bar called the Snacker.

This remains a core candy bar in their line, along with the King (made with peanut butter nougat and banana ganache), PB&J, Lime-in-the-Coconut, and S'more (featuring homemade graham cracker, smoked ganache, and toasted marshmallow). Liddabit is committed to using as many local ingredients as possible; for their beer and pretzel caramels, suppliers include Brooklyn Brewery and Martin's Pretzels. They also source directly from many small and family-owned businesses, such as Ronnybrook Farm Dairy, Taza Chocolate, and Salvatore Bklyn. After changing kitchens a few times, Liddabit now works out of a commercial kitchen space in Sunset Park, alongside many other makers, including Robicelli's and previously La Newyorkina.

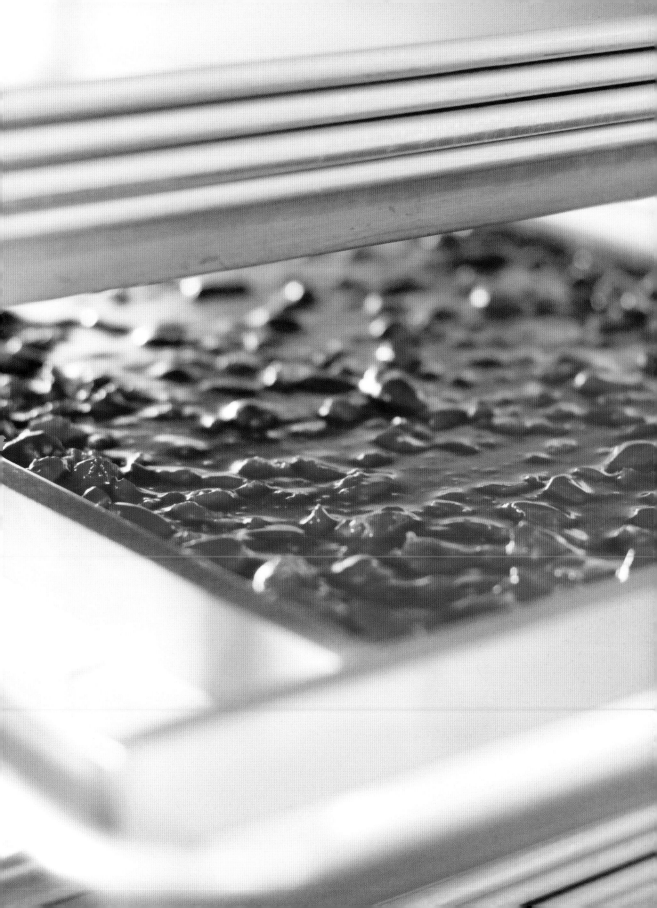

Using high-quality, locally sourced ingredients, such as Brooklyn Brewery beer for their beer and pretzel caramels, Liz and Jen mix up a batch of their specialty candy.

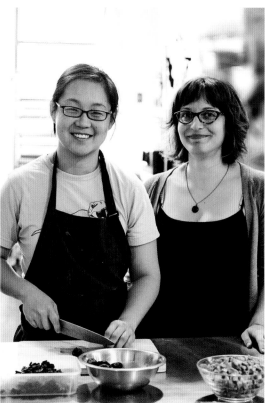

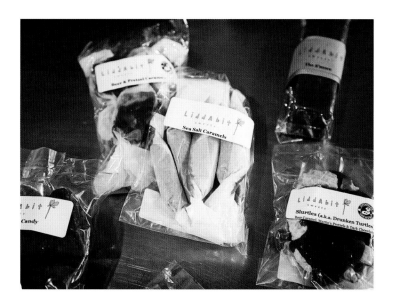

What did you look for in a studio space?
When we outgrew our first kitchen in Williamsburg, we had a chance to share space full-time in Bedford-Stuyvesant. There was a lot more room, and parking, but it was a third-floor walkup—not ideal for carrying thirty-pound boxes of chocolate and sixty-pound pails of glucose syrup up all the concrete steps. Now we're in a real commercial space, with plenty of dry storage and walk-in fridges and freezers and a freight elevator and everything. We'll be happy here for a while.

What is the most satisfying part of your making process? For me, I think it will always be the moment I take a bite of something we make— something I haven't had in a while, maybe— and think, "man, this is really, really good."

What is the best part of working with your hands? The sense of accomplishment. Working in food is grueling, physically and mentally; there's a lot of heavy lifting and tedious and repetitive motion. But after a long day in the kitchen, it's so satisfying to see a speed rack full of stuff that you made.

What do you enjoy most about being your own boss? It's pretty amazing to step back once in a while and acknowledge that we built this whole company from scratch; just our savings, help from our families, and our own blood, sweat, and tears. We're really bad at talking ourselves up, so periodically one of us will just look at the other and go, "can you believe we started all this?"

Do you barter with or purchase from other Brooklyn makers? All the time! People in this community are incredibly generous. We've traded candy for ice cream, meat, veggies, books. We're not rich, so it makes a lot of sense to trade in what we make. I think it's a really important part in ascribing value to what we make, and not just treating it as a commodity.

*All questions answered by Liz Gutman

La Newyorkina

who	**Fany Gerson**
location	**Sunset Park**
from	**Mexico**
years in Brooklyn	**since 2011**

Fany Gerson loves sweets. For many years, she honed her skills as a pastry chef. After spending a year traveling through her home country, researching and writing her first book, *My Sweet Mexico*, she returned to the city with a need to share the sweets of her childhood with New Yorkers. She decided to start her mission with *paletas* (ice pops), Mexico's traditional frozen treat. Before opening a store, Fany took her pops to street markets as a way to test her product and to create a direct connection with her customers. In 2010, Fany began selling her paletas at the Hester Street Fair in Manhattan's Lower East Side, and La Newyorkina was born.

For Fany, introducing new frozen flavors—sweet, as well as tart and spicy, such as avocado, tamarind, mango-chili, grapefruit, pineapple-jalapeno, coconut, and corn—to the people of the city she now calls home is a highlight of the job. One of her favorite summer combinations is mango on the outside and chamoy (pickled plum juice) flavor on the inside. In the summer of 2011, Fany also started selling at the outdoor New Amsterdam Market in Lower Manhattan, where she expanded into Mexican-inspired ice cream and toppings. She has seasonal carts on the High Line elevated park in Chelsea and at Rockaway Beach in Queens as well.

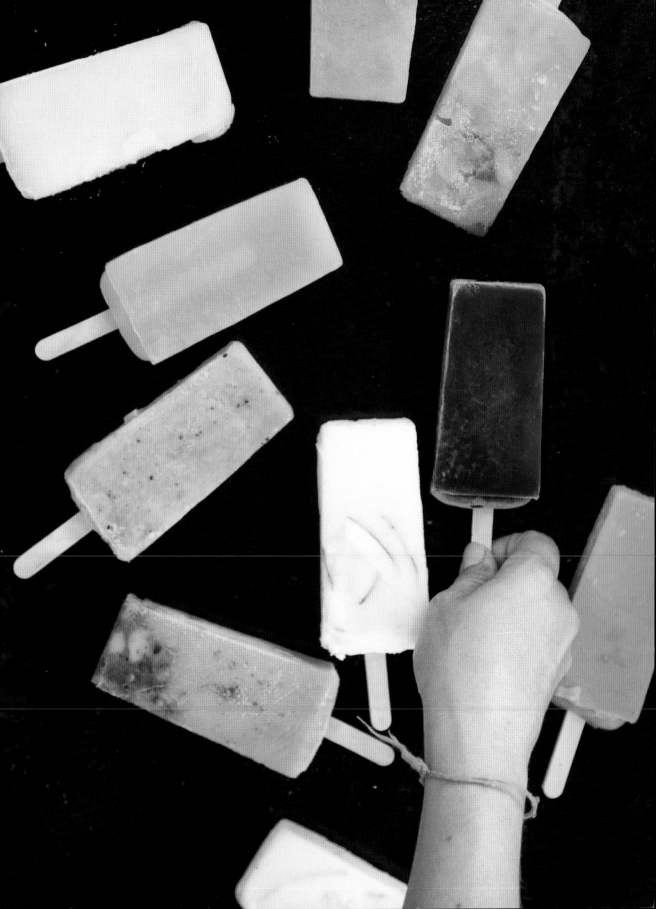

From an industrial kitchen
in Sunset Park, Fany brings
the taste of Mexico to
her frozen treats, mango-
chili and prickly pear.

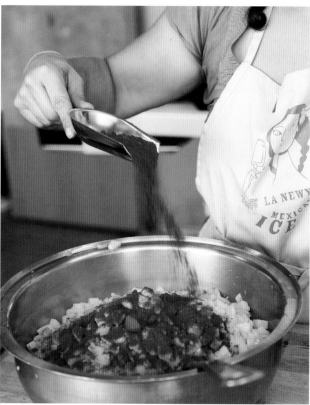

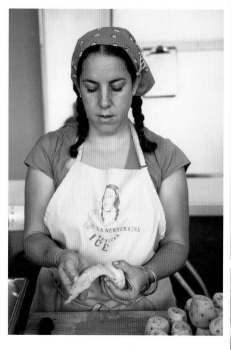

Describe your toolkit in detail. For the popsicles, the main equipment is the popsicle machine, which is a flash freezer that works by circulating an antifreeze liquid. Other main tools include a refractometer, a tool that helps align sticks, Vita-Prep (a commercial food blender), molds, scale, and basic kitchen tools, including bowls, pots, and colanders.

Where do you source the ingredients used in your work? Many ingredients are obtained at Latin food markets or wholesale vendors, Essex Street Market, and farmers' markets. I am constantly searching for specific flavors and foods and I always bring back ingredients like particular chiles and chocolate from Mexico.

What is the most satisfying part of your making process? The most satisfying part is sharing some of the wonderful culture that I was fortunate to grow up with.

Where did you learn your craft? Making popsicles isn't learned through cooking school but trial and error. I did have a lot of experience eating countless paletas growing up in Mexico.

How did you come up with the name of your business? According to some, after I had lived in the city for ten years, I could call myself a New Yorker. One friend suggested La Newyorkina for my business, meaning the girl from New York (inspired by La Michoacana, the most common popsicle shops in Mexico). La Newyorkina also explains who I am; I feel like a New Yorker but the name is in Spanish because I am Mexican in root and heart.

How important is community to what you do? Very much so. I come from a culture that is rooted in community. It's an incredible support system that allows bouncing of ideas, leaning on one another, sharing experiences (both good and bad)—it's what really makes it all worth it.

> The most satisfying part is sharing some of the wonderful culture that I was fortunate to grow up with.

Robicelli's

who	**Alison and Matt Robicelli**
location	**Sunset Park**
from	**Brooklyn, New York**

Alison and Matt Robicelli are a husband-and-wife baking team, creating delicious goods, such as cupcakes, whoopie pies, and brownies. In 2005, on the night they met, Alison, a former pastry chef apprentice, and Matt, a graduate of the French Culinary Institute, discussed starting a business together. Their first endeavor in 2008 was a gourmet food shop in Bay Ridge. Both Brooklyn natives (Alison is the fourth generation of her Italian family to live in Bay Ridge, and Matt's family moved to Sunset Park when he was one), they wanted to share the specialty items they loved with their neighbors. The store's most successful products were the Robicellis' own cupcakes, made with noteworthy flavor combinations influenced by traditional desserts. They soon decided to branch out and start selling their baked goods at local markets and to other businesses.

With high-quality ingredients and inspired names, the Robicellis' cupcakes developed a huge following. They currently have over two hundred cupcake flavors in rotation, changing on a weekly basis, including Chicken n' Waffles, Tiramisu, Sweet Potato Pie, the Liddabit (chocolate cake, caramel-nougat buttercream, ganache, caramel, and roasted peanuts—named after their fellow Brooklyn makers and kitchenmates), and a collection dedicated to *The Golden Girls*.

Family, including the couple's two young children, Atticus and Toby, is the heart of the Robicellis—and family means Brooklyn. When asked if they would ever leave the borough, Alison replied, "When you grow up here, where can you go? How do you top this?"

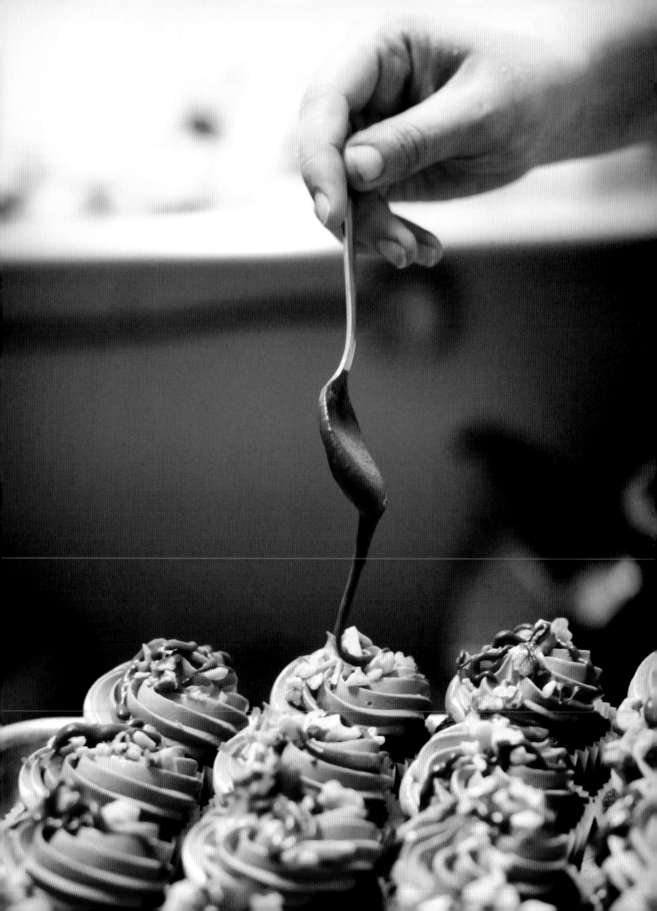

When you grow up here,
where can you go?
How do you top this?

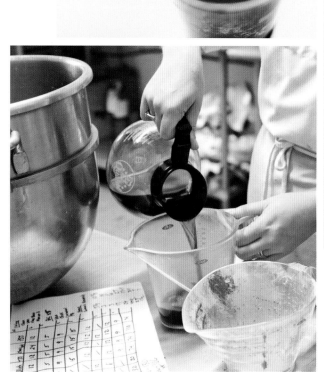

Each week, Alison and Matt
select a few signature cupcakes
from over two hundred flavors.
Key ingredients include jelly
for the PB&J and coffee for the Bea
Arthur (coffee-infused chocolate
cake, cheesecake buttercream,
and espresso ganache).

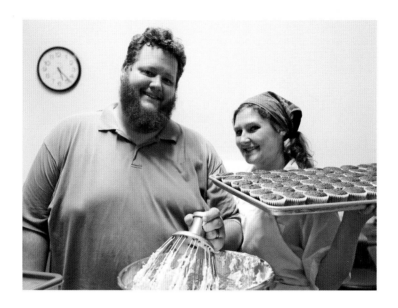

How has Brooklyn influenced your work?
Brooklyn is who we are. People who grow up here identify with the motherlands of their families— I will always be an Italian-American. We hold onto our roots in Brooklyn—we remember what people sacrificed for us to have a shot at the American dream. What's amazing, however, is that even though we were raised in our ethnic culture, we were also raised in the Irish, Chinese, Polish, Mexican, Russian, Haitian, etc. cultures of our friends. The "authentic" ethnic experiences that so many people travel the world looking for were in the houses of our neighbors. We grew up in a world where we were always exposed to and trying new things. In our cooking, we draw from global influences with ease, because our childhoods were filled with these flavors in the same way most Americans grow up with hot dogs and hamburgers.

Did you have another career before starting your current business? Matt was a FDNY paramedic, but his career ended on 9/11 when he was badly injured after the collapse of WTC 7. I built sets and stage managed off-off-Broadway shows.

If you were to make a Brooklyn cupcake, what would it be? We have lots of Brooklyn cupcakes:
Dom DeLuise (Italian Bensonhurst)
Risekreme (Scandinavian Bay Ridge)
The Aris (Greek Bay Ridge)
Baklava (Syrian Bay Ridge)
Chicken n' Waffles (Crown Heights)
Egyptian Cobra (Middle Eastern Bay Ridge)
Green Tea Mandarin (Cantonese Sunset Park)
Odessa (Russian Brighton Beach)
Mango Coconut (West Indian Crown Heights)
Abuelita (Mexican Sunset Park)
Ebinger (old school Brooklyn Blackout)
I don't think there could possibly be just one. That's not what Brooklyn has ever been about. We're not homogenous, and we never wanted to be.

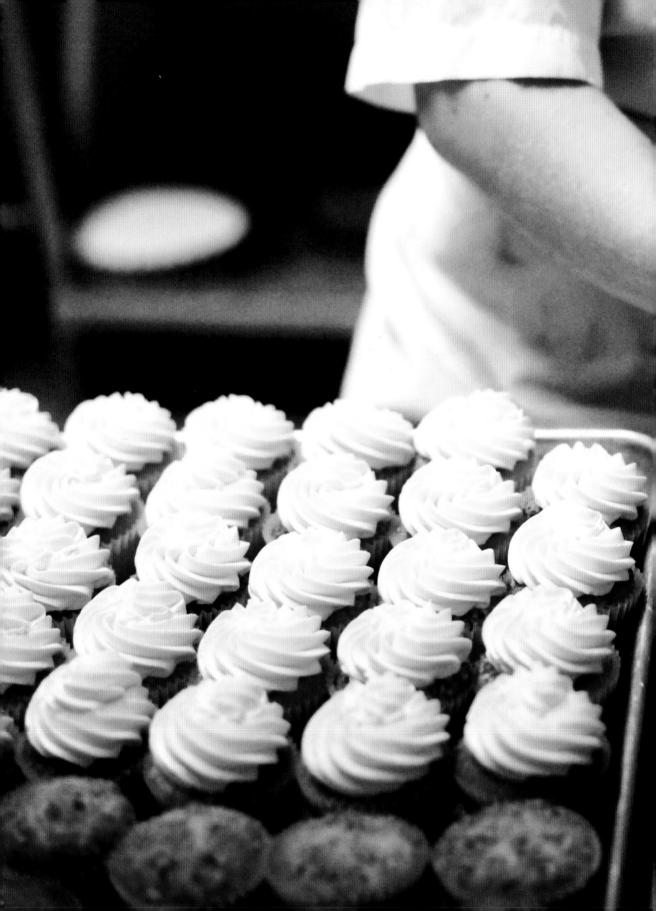

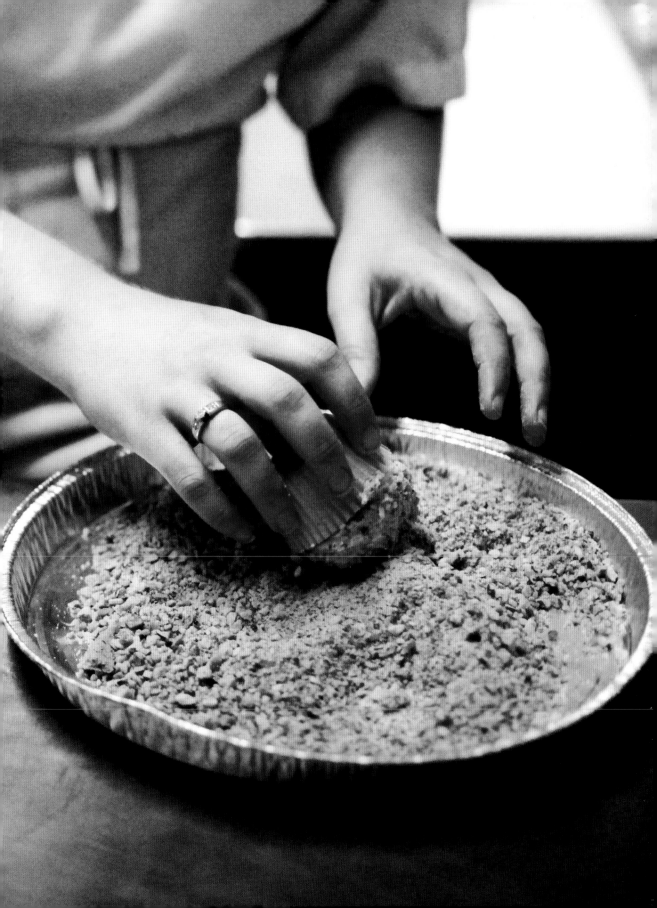

APPENDIX

Makers Index*

pp. 26–31

Bellocq Tea Atelier
bellocq.com
104 West Street
Greenpoint

pp. 84–87

Blue Bottle Coffee
bluebottlecoffee.net
160 Berry Street
Williamsburg

pp. 16–21

Clam Lab
clamlab.com
Greenpoint

pp. 146–51

Elephant Ceramics
elephantceramics.com
Red Hook

pp. 60–65

Erin Considine
erinconsidine.com
Williamsburg

pp. 38–41

Fay Andrada
fayandrada.com
Greenpoint

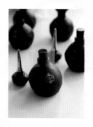

pp. 66–69

Fleabags
fleabg.com
Williamsburg

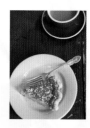

pp. 116–19

Four & Twenty Blackbirds
birdsblack.com
439 Third Avenue
Gowanus

pp. 22–25

hOmE
home-nyc.com
Greenpoint

pp. 112–15

The Jewels of New York
thejewelsofny.com
Brooklyn Heights

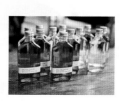

pp. 102–7

Joya Studio
joyastudio.com
Clinton Hill

pp. 94–99

Kings County Distillery
kingscountydistillery.com
Sands Street Gate, No. 121
Brooklyn Navy Yard

pp. 156–59

La Newyorkina
lanewyorkina.com
Sunset Park

pp. 88–93

Lady Grey Jewelry
ladygreyjewelry.com
Bushwick

pp. 108–11

Lena Corwin
lenacorwin.com
Fort Greene

pp. 152–55

Liddabit Sweets
liddabitsweets.com
Sunset Park

pp. 120–25

Lotta Jansdotter
jansdotter.com
131 Eighth Street
Gowanus

pp. 70–73

Mast Brothers Chocolate
mastbrothers.com
111 North Third Street
Williamsburg

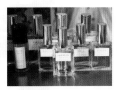

pp. 52–55

MCMC Fragrances
mcmcfragrances.com
Greenpoint

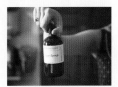

pp. 74–77

Morris Kitchen
morriskitchen.com
Williamsburg

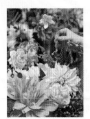

pp. 42–47

Nicolette Camille
nicolettecamille.com
Greenpoint

pp. 32–37

Odette New York
odetteny.com
Greenpoint

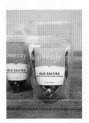

pp. 132–35

Ovenly
ovenlynyc.com
31 Greenpoint Avenue
Greenpoint

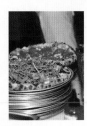

pp. 56–59

Paulie Gee's
pauliegee.com
60 Greenpoint Avenue
Greenpoint

pp. 136–39

—

PELLE
pelledesigns.com
390 Van Brunt Street
Red Hook

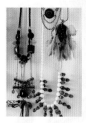

pp. 126–31

—

Reverie
reverienyc.com
Park Slope

pp. 160–65

—

Robicelli's
robicellis.tumblr.com
Sunset Park

pp. 140–45

—

Saipua
saipua.com
147 Van Dyke Street
Red Hook

pp. 78–83

—

Shabd
shabdismyname.com
Williamsburg

pp. 48–51

—

Wiksten
wikstenmade.com
Greenpoint

*Makers with addresses noted are
restaurants, cafes, or stores open to the public.

Further Reading

Blue Bottle Coffee — The Blue Bottle Craft of Coffee: Growing, Roasting, and Drinking, with Recipes, James Freeman and Caitlin Freeman, with Tara Duggan

The Jewels of New York — Cooking with the Jewels of New York, Lisel Arroyo and Diana Yen

La Newyorkina — My Sweet Mexico: Recipes for Authentic Pastries, Breads, Candies, Beverages, and Frozen Treats, Fany Gerson

Paletas: Authentic Recipes for Mexican Ice Pops, Shaved Ice, and Aguas Frescas, Fany Gerson

Lena Corwin — Brooklyn Diary, Lena Corwin

Maps, Lena Corwin

Printing by Hand: A Modern Guide to Printing with Handmade Stamps, Stencils, and Silk Screens, Lena Corwin

Lotta Jansdotter — Lotta Jansdotter's Handmade Living: A Fresh Take on Scandinavian Style, Lotta Jansdotter

Lotta Jansdotter's Simple Sewing: Patterns and How-to for 24 Fresh and Easy Projects, Lotta Jansdotter

Lotta Prints: How to Print with Anything, from Potatoes to Linoleum, Lotta Jansdotter

Open Studios with Lotta Jansdotter: Twenty-Four Artists' Spaces, Lotta Jansdotter and Jenny Hallengren

Nicolette Camille — Bringing Nature Home: Floral Arrangements Inspired by Nature, Ngoc Minh Ngo with Nicolette Owen

Classes and Tours

Erin Considine

Erin Considine teaches classes on jewelry and natural dyes at the Textile Arts Center in Park Slope, see textileartscenter.com.

Kings County Distillery

The distillery is open for tours and tastings on select days, see kingscountydistillery.com.

The Little Flower School (Nicolette Camille and Saipua)

Nicolette Owen and Sarah Ryhanen hold workshops at their studios and on the road, see little-flower-school.blogspot.com.

Lotta Jansdotter

Lotta Anderson offers classes on stenciling, surface printing, and more at her studio in Gowanus, see jansdotter.com/workshops.

The Jewels of New York

Diana Yen and Lisel Arroyo host events (cooking workshops and dinners), see thejewelsofny.com/events.

Mast Brothers Chocolate

The Mast Brothers Chocolate tasting room is open to the public and they also offer tours of their factory and special events, see mastbrothers.com.

MCMC Fragrances

Anne McClain offers classes out of her Greenpoint studio, see mcmcfragrances.com/Classes.html.

Shabd

Shabd Simon-Alexander teaches classes on the art of tie-dye at the Textile Arts Center in Park Slope, see textileartscenter.com.

Brooklyn Favorites*

RESTAURANTS AND CAFES

Bakeri
bakeribrooklyn.com
150 Wythe Avenue
Williamsburg

Diner
dinernyc.com
85 Broadway
Williamsburg

Eat
eatgreenpoint.com
124 Meserole Avenue
Greenpoint

The Farm on Adderley
thefarmonadderley.com
1108 Cortelyou Road
Ditmas Park

Frankies Spuntino
frankiesspuntino.com
457 Court Street
Carroll Gardens

Home Made
homemadebklyn.com
293 Van Brunt Street
Red Hook

James
jamesrestaurantny.com
605 Carlton Avenue
Prospect Heights

Lucali
575 Henry Street
Carroll Gardens

Marlow and Sons
marlowandsons.com
81 Broadway
Williamsburg

Roberta's
robertaspizza.com
261 Moore Street
Bushwick

Saltie
saltieny.com
378 Metropolitan Avenue
Williamsburg

Seersucker
seersuckerbrooklyn.com
329 Smith Street
Carroll Gardens

Vinegar Hill House
vinegarhillhouse.com
72 Hudson Avenue
Vinegar Hill

LEISURE

Brooklyn Academy of Music
bam.org
30 Lafayette Avenue
Fort Greene

Brooklyn Botanical Garden
bbg.org
900 Washington Avenue
Prospect Heights

Brooklyn Bowl
brooklynbowl.com
61 Wythe Avenue
Williamsburg

Brooklyn Museum
brooklynmuseum.org
200 Eastern Parkway
Prospect Heights

Eagle Street Rooftop Farm
rooftopfarms.org
44 Eagle Street
Greenpoint

Nitehawk Cinema
nitehawkcinema.com
136 Metropolitan Avenue
Williamsburg

Brooklyn Bridge Park
brooklynbridgepark.org

Coney Island
coneyisland.com

Prospect Park
prospectpark.org

*Jennifer Causey's top Brooklyn picks for
eating, shopping, and enjoying downtime

SHOPS		MARKETS	
Bird	shopbird.com 220 Smith Street Cobble Hill	Brooklyn Flea	brooklynflea.com Fort Greene and Williamsburg
	316 Fifth Avenue Park Slope	DeKalb Market	dekalbmarket.com Downtown Brooklyn
	203 Grand Street Williamsburg	Smorgasburg	brooklynflea.com/ smorgasburg Williamsburg
Bklyn Larder	bklynlarder.com 228 Flatbush Avenue Prospect Heights	Hester Street Fair	hesterstreetfair.com Lower East Side Manhattan
Brook Farm General Store	brookfarmgeneralstore.com 75 South Sixth Street Williamsburg	The High Line	thehighline.org Chelsea, Manhattan
Brooklyn Kitchen	thebrooklynkitchen.com 100 Frost Street Greenpoint	New Amsterdam Market	newamsterdammarket.org Lower Manhattan
Catbird	catbirdnyc.com 219 Bedford Avenue Williamsburg		
Darr	shopdarr.com 369 Atlantic Avenue Boerum Hill		
Greenlight Bookstore	greenlightbookstore.com 686 Fulton Street Fort Greene		
In God We Trust	ingodwetrustnyc.com 70 Greenpoint Avenue Greenpoint		
	129 Bedford Avenue Williamsburg		
Marlow and Daughters	marlowanddaughters.com 95 Broadway Williamsburg		
Modern Anthology	modernanthology.com 68 Jay Street Dumbo		
Moon River Chattel	moonriverchattel.com 62 Grand Street Williamsburg		
Smith and Butler	smithbutler.com 225 Smith Street Cobble Hill		

ACKNOWLEDGMENTS

I would like to offer deep gratitude to all the wonderful makers who graciously allowed me into their studios to see their processes. I was able to live vicariously through each and every one of you, and I will always be appreciative.

Thank you to my parents, John and Marcia Causey, for raising me in an environment surrounded by creativity and making, and for allowing me to live my dreams. A special thank you to my mom for listening to me talk about the project, even though she did not fully understand it.

And for the friends who have helped me a great deal with this project by listening and offering encouragement: Gavin Young, Jenifer Altman, and Jennifer Caswell. A giant thank you to Rachel Plotkin Holtzclaw for her support and countless hours of editing in the wee hours to help make this project possible and to give me the motivation to keep going. Thank you to Linda Ketelhut for listening to me talk about the project back in the beginning stages on our long, crazy road trip from Austin to Marfa, for brainstorming with me, and for continuing to listen to me talk about it for endless hours ever since.

Thank you to Princeton Architectural Press for making this book possible and putting my work out into the world, with a special thanks to my editor, Megan Carey. Without Megan, this book would not be here. Thank you, Megan, for all your hard work and all the hours you put in making the book so special. Thank you to the design team at PAP, especially Elana Schlenker for transforming my vision onto the page.

Thank you to everyone who has emailed to offer suggestions and encouragement. And finally, the biggest thank you goes to all the makers out there, for inspiring us all to live a more thoughtful and tactile life.

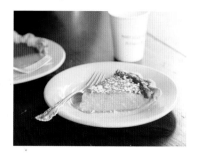

Published by
Princeton Architectural Press
37 East Seventh Street
New York, New York 10003

Visit our website at www.papress.com.

Editor: Megan Carey
Editorial Assistant: Fannie Bushin
Designer: Elana Schlenker

Special thanks to: Bree Anne Apperley, Sara Bader,
Nicola Bednarek Brower, Janet Behning, Carina Cha,
Andrea Chlad, Benjamin English, Russell Fernandez, Will Foster,
Jan Haux, Diane Levinson, Jennifer Lippert, Jacob Moore,
Gina Morrow, Katharine Myers, Margaret Rogalski,
Dan Simon, Sara Stemen, Andrew Stepanian, Paul Wagner,
and Joseph Weston of Princeton Architectural Press
—Kevin C. Lippert, publisher

Library of Congress Cataloging-in-Publication Data
Causey, Jennifer, 1973–
Brooklyn makers : food, design, craft, and other
scenes from the tactile life / Jennifer Causey. — First edition.
pages cm
ISBN 978-1-61689-074-2 (pbk.)
1. Portrait photography—New York (State)—New York.
2. Artisans—New York (State)—New York—Portraits.
3. Brooklyn (New York, N.Y.)—Pictorial works. I. Title.
TR681.A69C38 2012
779.9747'23—dc23
2012012057